LEGENDS
AND LORE
OF
SOUTH
CAROLINA

LEGENDS AND LORE
OF
SOUTH CAROLINA

SHERMAN CARMICHAEL
ILLUSTRATIONS BY
KARLEIGH HAMBRICK

THE
History
PRESS

Published by The History Press
Charleston, SC 29403
www.historypress.net

Copyright © 2012 by Sherman Carmichael
All rights reserved

First published 2012

Manufactured in the United States

ISBN 978.1.60949.748.4

Library of Congress Cataloging-in-Publication Data

Carmichael, Sherman.
Legends and lore of South Carolina / Sherman Carmichael.
p. cm.
ISBN 978-1-60949-748-4
1. South Carolina--Social life and customs--Anecdotes. 2. South Carolina--History, Local-
-Anecdotes. 3. South Carolina--Biography--Anecdotes. 4. Folklore--South Carolina. 5.
Legends--South Carolina. I. Title.
F269.6.C38 2012
398.209757--dc23
2012027918

CONTENTS

CONTENTS

CONTENTS

PREFACE

L egends and myths are not built on nothing. They are not simply made-up stories. They always contain a modicum of truth.

Traditionally, South Carolina is known for its historical hauntings. What is it that makes South Carolina home to so many ghosts? Is it South Carolina's turbulent and tragic past that has held so many spirits here? Whatever the reason, from the lonely highway to the mist-shrouded beaches, South Carolina is where the unexplained meets the every day. Haunted houses, haunted highways, mysterious monsters, ghost-infested plantations and many other unexplained happenings abound in South Carolina.

The dark, mysterious side of South Carolina has inspired many books. Truth be said, no fiction can compare to the accounts of hauntings and other mysterious events in South Carolina. Scientists won't admit that ghosts and other supernatural occurrences exist. Are these highly educated people so close-minded to believe that just because it doesn't fit into their way of thinking or they can't take it into a lab and take it apart it doesn't exist? If they can't explain it, they just call it misidentification or mass hallucinations. Science says it cannot accept imaginative solutions because they have no demonstrable foundation.

Most people in South Carolina have come to terms with the fact that we are not alone. Whether these stories are true or just campfire tales, they continue to survive the test of time.

ACKNOWLEDGEMENTS

Thank you to Beverly Carmichael for the many hours of proofreading and correcting my mistakes and to all the others who made this book happen: Ric Carmichael, April Asaro, James Ebert, Lynne Ebert, Garth Holt, Matt McColl, Cindy James, Barbara Nuessle and Dave Bilderback. Without these important people, neither of my books would have been possible.

SOUTH CAROLINA FACTS

South Carolina was first visited by Spanish explorers in the early 1500s.

South Carolina was named to honor King Charles I.

South Carolina was the eighth state to become part of the United States. It became a state on May 23, 1788.

South Carolina was admitted as one of the original thirteen colonies in 1788.

Before being known as the Palmetto State, it was known as the Iodine State.

South Carolina was the birthplace of Andrew Jackson, seventh president (1829–37).

The first battle of the Civil War took place at Fort Sumter

South Carolina was the first state to secede from the Union in 1860.

The state flag was adopted in 1861.

The only major-league baseball player to wear the name of his hometown on his uniform was pitcher Bill Voiselle. He wore number 96.

Duncan Park Baseball Stadium in Spartanburg is the oldest minor-league stadium in America.

The first boll weevil found in South Carolina is on display in the Pendleton District Agricultural Museum.

Lake Murray is the only lake in South Carolina to house a monster. The Lake Murray Monster was first seen in 1973.

Johnston is known as the peach capital of the world.

Sweetgrass basket making has been part of the Mount Pleasant community for over three hundred years.

The introduction of tobacco in 1894 rocketed Mullins into being the tobacco capital of South Carolina.

The Lake City tobacco market was established in 1898 and is one of the largest markets in South Carolina.

The Spartanburg Downtown Memorial Airport was the first airport to open in South Carolina in October 1927.

The Upper Whitewater Falls is the highest cascade in eastern America; it descends for nearly 411 feet.

State capital: Columbia

Largest city: Columbia

Smallest county: McCormick, 360 square miles

Largest county: Horry, 1,134 square miles

Highest mountain: Sassafras Mountain, 3,560 feet

Largest island: John's Island

Largest lake: Lake Marion, 172.8 square miles

State motto: "While I breathe, I hope."

State song: "Carolina"

State nickname: Palmetto State

State dance: shag

State bird: Carolina wren

State game bird: wild turkey

State animal: whitetail deer

State butterfly: eastern tiger swallowtail

State insect: Carolina mantid

State fish: striped bass

State dog: Boykin spaniel

State reptile: loggerhead turtle

State spider: Carolina wolf spider

State amphibian: spotted salamander

State shell: lettered olive

State flower: yellow jessamine

State tree: sabal palmetto

State fruit: peach

State stone: blue granite

State gemstone: amethyst

State beverage: milk

State hospitality beverage: tea

State folk dance: square dance

State waltz: Richardson waltz

THE UPSTATE

CAMPBELL COVERED BRIDGE

Of the many covered bridges built in South Carolina, Campbell Covered Bridge is the last remaining one. It was built in 1909 and is located near the small town of Gowensville in Greenville County. It is the only authentic historic survivor of the many covered bridges built. Campbell Covered Bridge is owned by Greenville County and is one of four covered bridges built in northeastern Greenville County in the early twentieth century. Charles Irwin Willis built the thirty-eight-foot-long, twelve-foot-wide bridge across the Beaver Dam Creek on Pleasant Hill Road. Lafayette Campbell, who owned 194 acres and a gristmill, allowed the bridge to be built on his property so it would be easier for the farmers in the area to bring their corn to be prepared at his mill.

Campbell Covered Bridge was closed to motor traffic in early 1981 and placed on the National Register of Historic Places in 2009. The Campbell Covered Bridge has been restored twice, first in 1964 by the Crescent Garden Club and again in 1990. More improvements and repairs were made in March 2001. Silvia Pittman owned the land around the bridge, and in 2005, she sold ten acres to Greenville County to construct a park around the bridge.

This bridge, like many other South Carolina bridges, has its mystery. But this one is not a ghost, not a mysterious death or a crying child or even a ghost light. This bridge has a family of trolls living under it. At least that's

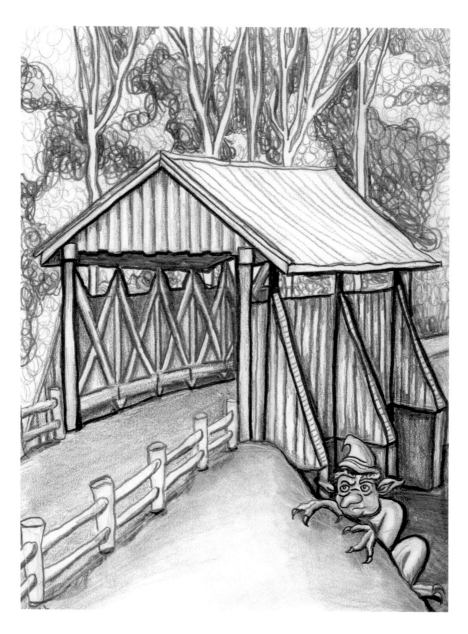

what some old-time mountain folk think. When trolls set up housekeeping under a bridge, no one crosses the bridge without getting permission from the trolls. Trolls often lure their victims to their deaths by making noises under the bridge. In the old days, those who were crossing the bridge and believed in trolls would leave offerings of food at the bridge. This was a

peace offering so the weary travelers would not meet an untimely death at the hands of the trolls. Trolls are a race of fearsome creatures from Norse mythology. There are many legends of different types of trolls, which include monsters of human appearance, ogres, fiendish giants, humanoid monsters and Neanderthal humans. In the middle ages, trolls were thought of as horrifying and even satanic creatures. Crucifixes, the name of Christ spoken aloud and other religious symbols would scare them away. Some believe they were demons that had fallen out of heaven and lived in subterranean hell.

UNION'S CRYBABY BRIDGE

Just before you get to Rose Hill Plantation in Union County, South Carolina, there is an old bridge with rusted steel frames on the top. This bridge, like many other bridges in South Carolina, is haunted. A tragedy happened there in the 1950s. After a fight with her husband, a young woman took her baby and walked away from her home. She walked for a while down a long dirt road trying to get her thoughts together. She walked onto the bridge and stood there for a while looking at her reflection in the water below. She could not come to terms with her problems, so she held up her baby and dropped it into the water. She watched as the baby drowned.

If you stop your car on the bridge at midnight and turn off the engine so there is complete silence, you can hear the faint cry of a baby and see the mother standing at the rail looking for her baby.

GREER'S HAUNTED BRIDGE

Devenger Road in Greer, South Carolina, is the location of another haunted bridge. The story here is a little different. One story is that a group of teenagers went to the bridge to see if the story of the haunting was true. They parked their car in the middle of the bridge, turned off the engine and put it in neutral. They sat there for a while with nothing happening. All of a sudden, the car started moving backward up the hill. As they cranked up and started to leave, the driver glanced in the rearview mirror and noticed a white truck coming up behind them. It seemed to come out of nowhere. It followed them for about two miles and then vanished.

Another story is about a group of teenagers who went to the bridge to check out the story. They looked over the side of the bridge and saw a small girl in a glowing white dress.

Another person reported stopping on the bridge twice, and his car rolled in a different direction each time.

ENOREE RIVER RAILROAD TRESTLE

This story dates back to the end of the Civil War. After burning Columbia, General Sherman's army was terrorizing the area. A group of refugees heard that Sherman's army was heading toward Greenville. Reports said that General Sherman's army would burn all towns, bridges and railroad trestles along the way. The refugees headed toward Spartanburg. After traveling for a while, they decided to take refuge under the train trestle that crossed the Enoree River. A young mother and her baby daughter were among the refugees. In order to keep the baby quiet, the mother held her hand over the baby's mouth. Sometime during the night, the baby suffocated. Members of the refugee party tried to bury the baby, but the mother refused to have her baby buried under a train trestle. The mother lost her mind and wouldn't let anyone near her and the baby. As the refugees moved on, the mother refused to go with them. As the party moved on, the mother, distraught over losing her only child, held the baby close to her and jumped from the trestle into the waiting water below. Some of the refugees looked back and witnessed the tragic incident. The refugees returned to the river only to find the lifeless baby floating in the river. They gave the child a Christian burial. The body of the mother was never found. General Sherman's army veered off to the east and never took the path that the refugees expected it to take.

If you walk slowly across the trestle or stand on it, you can hear the muffled cry of a baby. Another story is that sometimes you can see a young woman walking down the riverbank near the trestle crying and looking into the river.

OAKWOOD CEMETERY, AKA HELL'S GATE

Oakwood Cemetery is Spartanburg's most haunted cemetery, or so some visitors say. Gravestones date back to the mid-1800s. There are reports of

a lot of strange things that happen in Hell's Gate. People who go into the cemetery report having a feeling of being watched even though there is no one else around—or is there. Unexplained noises can be heard from different locations in the graveyard, some from a distance and some from close up even though there's nothing there to make the noises. There have been reports of cameras automatically shutting off while people are trying to take pictures and fresh batteries going dead. Pictures of glowing orbs have been taken at different locations around the cemetery, mostly in the older part. On some occasions, shadowy figures have been reported moving around the cemetery, while others report seeing lights moving around in the adjacent woods. There are several reports of apparitions of children being seen with a whitish mist around them. One rumor is that the cemetery serves as a gate to hell.

THE JESUS MONUMENT

Every town in South Carolina has a haunted graveyard, but Spartanburg is home to a more unusual graveyard. On the east side of Spartanburg located near a very busy highway is an ordinary-looking cemetery. Headstones of different shapes and sizes line the cemetery. Bright-colored flowers adorn many of the graves. Just passing by, you would not think there's anything unusual about this cemetery. But there's nothing ordinary about this graveyard.

Like many other cemeteries that dot the countryside, there's a monument in the middle depicting Jesus. So what is so unusual about this monument? Some people say you can see the statue of Jesus move, giving the impression that he is about to step down. To see the statue move, you have to park in front, turn on your bright lights and watch the statue. Is this an optical illusion or a religious encounter?

THE DEVIL'S BRIDGE

Stories about haunted bridges and bridges with bizarre effects dot the United States. Every community has a haunted bridge. From time to time, you run into one that is a little different. Spartanburg has one of those different bridges. The story that surrounds this bridge is more of a going-against-

nature occurrence than a haunting. Why this has to be tested late at night is another mystery. Park your car in the center of the bridge, put it in neutral and then turn off the engine. Wait a few minutes, and it will begin to roll as if being pushed forward. Regardless of which direction the car is parked, it will roll off the bridge. Is somebody or something pushing the car off the bridge, or is this some natural or maybe supernatural event occurring?

HANGMAN'S TRESTLE

Many old railroad trestles have mysterious stories behind them. An old, arched concrete train trestle on the west side of Spartanburg has an unusual haunting. Like many other stories handed down over the years, much of the information and the exact dates have been lost in time. According to what's left of the legend, a woman was hanged from the train trestle. I could not find a reason for the hanging or any facts to back up this legendary hanging.

Some people say you can park your car under the trestle and sit and wait. When you hear a train whistle in the distance, something will start dripping on your car. It is supposed to be the blood of the woman who was hanged there. Other (unofficial) information I found is that a young girl who lived by the tracks was murdered, and a woman was later raped near the same spot of the murder.

HAGOOD GRISTMILL

One of the finest examples of nineteenth-century technology can be found at the Hagood Mill site, located on Highway 178 just three miles north of Pickens. It is one of the oldest known gristmills in South Carolina that still produces grain products and still uses the original wheel components. The Hagood Mill (not known as Hagood Mill at that time) was owned by William Jennings in 1773. For whatever reason, he sold it to Benjamin Hagood in 1823. The original gristmill was built in 1826. It ran for nineteen years and then, in 1845, was rebuilt by Benjamin Hagood's son, James. Hagood Mill was willed to John Hagood in 1865. John Hagood died in 1879 and left the mill to Ester Hagood. She passed away in 1891 and left it to James Hagood. The gristmill, following the family heirs, was inherited by Bruce Hagood in 1958.

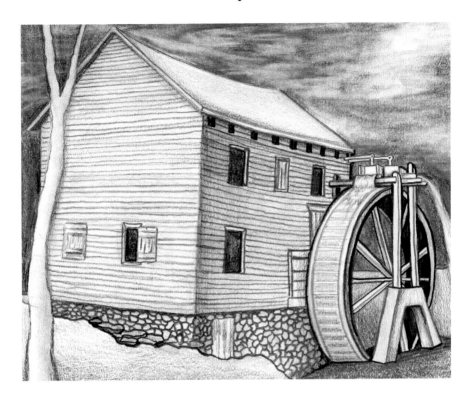

The Hagood Mill ran commercially until 1966. On December 11, 1972, the Hagood Mill was listed in the National Register of Historic Places. In 1973, the gristmill and surrounding property were donated to the Pickens County Museum Commission.

Hagood Mill is located on Hagood Creek, a tributary of the Twelve Mile River. The water from the creek was directed to the mill by an earthen headrace (a ditch). At least eighty feet of the headrace is made of wood. Early construction methods are shown by the hand-hewn logs notched and pegged together to form the frame of the mill. The wooden water wheel is twenty feet in diameter and four feet wide. With the wear on the wheel from the many years of work, some repairs needed to be done. Around 1975, the wheel and the mechanical parts were rebuilt. When rebuilding the wheel, they used as many of the original parts as possible. The ring gear is eighteen feet in diameter. The gristmill houses two granite millstones weighing about 1,600 pounds each.

The gristmill is open from 10:00 a.m. until 4:00 p.m. on the third Saturday of each month.

Anderson County Crybaby Bridge

After doing research for my Internet series "A Storied Journey Through South Carolina's Mysterious Past," I believe every county in South Carolina has a crybaby bridge. The bridge near the intersection of High Shoals Road and Broadway Lake Road just southeast of Anderson is haunted by a baby and a car.

A local legend tells of a mother and her baby driving across the bridge. They wrecked on the bridge, and both were killed at the scene. The legend doesn't say what caused the wreck, if another car was involved or if other people lost their lives. The legend goes on to tell about people seeing a car crossing the bridge but never getting to the other side. It vanishes somewhere on the bridge. Other witnesses report hearing a baby crying in the distance. I have not found any reports of the mother returning to the bridge.

The Hound of Goshen

In the years before the Civil War broke out, many wealthy farmers bought summer homes in the mountains of South Carolina. They would use these homes as a place to vacation and a means of escaping the summer heat and pesky little mosquitoes that visit us during the summer months.

In Union County near the Newberry County line was a small township called Goshen Township. It was located on the Old Buncombe Road, which at that time was the main stage route for the area. Sometime between 1850 and 1852, an old peddler and his white dog were passing through Goshen Township peddling his wares. At the same time he was passing through, a murder of the most gruesome nature occurred. The murder shocked the people of Goshen Township. Never had they seen anything like this. There were no leads and no suspects. The citizens were looking for someone on whom to blame the murder. The peddler, a stranger in town with no one to stand up for him, was accused of the crime. A hasty trial—if you could call it a trial—was held, and the peddler was found guilty of murder. The peddler pleaded his innocence, but no one would listen. His pleas fell on deaf ears. The citizens felt sure they had convicted the right man. The peddler was taken out and publicly hanged.

The old white hound stayed by his master's side during the hanging. Several of the good citizens tried to run the dog off, but the faithful old hound

kept returning. He would not leave his master. For days after the old peddler was buried, the dog stayed by the peddler's graveside and howled constantly. The citizens of Goshen Township, tired of hearing the old hound's howling, decided to put an end to it by stoning the dog to death. The old white hound dog fell by his master's grave and breathed his last. The lifeless dog was taken down the road and thrown into the woods—not a proper resting place for a loyal dog.

Shortly after this, travelers along this stretch of the road reported seeing a big white hound that would come running out of the woods and jump at their horses. The dog was described as large in appearance, almost ghostly white and with eyes like burning coals. Some of the travelers were brave enough to strike at the dog with their whips only to see them pass right through the ghostly white beast. The dog would follow the travelers until they reached the graveyard where the old peddler was buried. It would run through the locked iron gates to the old peddler's grave and then disappear.

In the 1800s, during a deathbed confession, a wicked old man confessed to the grisly murder, therefore clearing the old peddler.

Dr. Douglas was an old country doctor who lived on Old Buncombe Road and served Goshen Township. As he made his rounds, the ghostly dog would accompany him down Old Buncombe Road. Until his death, he maintained that the dog was his friend and that he was not afraid of the ghost dog.

By 1936, the road had been paved and the horse and buggy was replaced by the automobile. Travelers on Old Buncombe Road still reported seeing the ghostly white dog but not as frequently as before. Some reports came in as late as 1998. The ghost of the old white hound still haunts Old Buncombe Road.

LONELY BRIDGE

Westminster is located in Oconee County. I have not been able to locate much information on its haunted bridge or the road it's on. The creek or branch that runs under the bridge is located near a sawmill or what used to be a sawmill. There are some reports that a girl drowned while swimming in the creek in the 1950s. People report hearing screams as the girl jumps in front of an on coming car. The girl vanishes before the car can stop.

ROCK HOUSE ROAD

Rock House Road in Blacksburg got its name from a rock house that was built there in the early 1800s. The house is still standing, but I'm not sure whether you can visit it.

There is a legend surrounding the Rock House and Rock House Road. There was a family living there in the 1800s that had a mentally impaired daughter. Because of the daughter's condition, the family felt she was an embarrassment. The father made her stay in the cellar during the day. They would not let her out for the family meals; her food was taken to her. At night, the father would give her a candle and let her go outside. One night, the girl decided to go a little farther than she normally did. She ventured into the woods that night. Not realizing how far she had walked, she discovered that she was lost. Before she could find her way back, the candle burned out. Now hopelessly lost in the dark, she wandered around. With no light, she could not find her way home. She died that night lost in the woods.

People have reported seeing a light resembling a candlelight moving around in the woods along Rock House Road.

WHITE WOLF HOLLOW

White Wolf Hollow is located near Kings Mountain State and National Parks in Blacksburg. There are a lot of graveyards located in the surrounding woods. This location is a popular hangout for teenagers. Coon hunters have used it from time to time to meet before going hunting.

White Wolf Hollow is reported to be haunted by several ghosts. Some people have reported seeing a light floating around in the woods that looks like a flashlight. Other people have reported seeing a large, catlike creature with red eyes. Another story dates back to the Civil War. A soldier was returning home from the war just to find out that his wife had not been faithful to him. Beside himself with anger from risking his life fighting for the South and the flower of southern womanhood only to find out that his wife had been cheating on him, he attacked his wife. During the struggle, he was attacked by her pet white wolf. The soldier killed his wife and the wolf. He disposed of her and the wolf's bodies in the creek near the bridge that leads to White Wolf Hollow. The ghosts of the soldier's wife and her pet white wolf still haunt the road. People have reported seeing a girl dressed in white with a white wolf beside her walking down the road.

White Wolf Road

Blacksburg is home to several ghost stories. Several unfortunate happenings have taken place on White Wolf Road, located near Kings Mountain State Park. The first story is about the murder of a man who was shot execution style beside his truck. His truck was then set on fire. No one ever knew the reason the man was killed, or at least no one ever told why. No one was charged for the man's murder, and it is still unsolved. People have reported seeing the ghostly apparition of the man's burnt truck driving with the lights on down White Wolf Road. No one has gotten close enough to it to see who or what is driving the truck. Has the ghost of the murdered person come back in search of the person or persons who took his life? Is this ghostly truck destined to drive endlessly down White Wolf Road?

Another story that originates on White Wolf Road involves another murder. A Civil War soldier, after serving his time, returned home to find that his wife had been unfaithful. He was beside himself with anger and, without thinking, killed his wife and her favorite pet, a white wolf-like dog. In order to hide the crime, the soldier cut his wife and the dog into pieces and threw them into a creek. Travelers along White Wolf Road have reported seeing a woman dressed in white with a wolf-like head walking aimlessly down the road.

Cherokee Falls Bridge

And now we journey to another haunted bridge in South Carolina. As much as we travel, we must cross at least a dozen haunted bridges in our lifetime. This time it's not a crybaby bridge. Cherokee Falls Bridge is located near Blacksburg.

I could not locate any record of the alleged incident on this bridge. Booger Jim and his wife lived near Cherokee Falls Bridge, and for whatever reason, in 1979 she decided to do old Booger Jim in. How she managed to pull this off is still a mystery. She tied jumper cables around Booger Jim's neck and to the side of the bridge. She then shoved Jim off the bridge, breaking his neck.

The story goes that since Booger Jim met his untimely death, his ghost has taken up residence under the bridge. Some people say that if you call his name three times, he will answer. There always seems to be some kind of ritual that is needed to attract the ghost. Others report seeing Booger Jim's ghost standing on the bridge. If you can get close enough to him, you can see the bruise marks on his neck made by the jumper cables.

THE SUPERMOON

On March 19, 2011, at 3:00 p.m. eastern time, the moon was closer to the earth than it's been in eighteen years. It was the short distance of 221,565 miles from earth. The moon's orbit around the earth is slightly elliptical. When our heavenly luminary is at its closest point, it's called a lunar perigee. Astronomers and astrologers called this the supermoon because of its size. At its peak, the supermoon was 14 percent larger and 30 percent brighter than it normally appears. The near coincidence of the full moon with perigee resulted in a large range of high and low tides. The higher tides came a few days after the perigee. One NASA astronomer said this was the biggest full moon you'll ever see.

There were supermoons in 1955, 1974, 1992 and 2005. These years had their share of extreme weather. Was it coincidence, or was it caused by the supermoon? There were other years when some people claim that there was a supermoon, but others say the moon was not big enough to be called a supermoon.

Those who believe that the supermoon causes natural disasters will find their proof; for others it's merely a coincidence. The last supermoon was in 2005, right around the time of the 2004 Indonesia 9.1 earthquake on December 26. On March 8, 2003, a perigee happened a little over an hour before the full moon, which was just days before the March 12–13 superstorm. Some say the lunar perigee caused the 1938 New England hurricane, the 1955 Hunter Valley floods, the 1974 cyclone Tracy in Australia, Hurricane Katrina in 2005 and the 2005 tsunami in Indonesia, even though that was several weeks before the perigee. But some think that's close enough. There was also a supermoon in 1992. Hurricane Andrew occurred on August 24, 1992.

The 2011 supermoon did not have any natural disasters tied to it. However, 2011 did have a natural disaster of epic proportion: the Japanese earthquake and tsunami. The 2011 supermoon was visible across South Carolina, but thankfully, no natural disasters struck South Carolina.

THE MIDLANDS

THE BRIDE OF WEST END

There are several different versions of this ghost bride story. The name of the bride and the location of her grave are unknown. The West End Cemetery is located in or near Newberry, South Carolina. One of the stories is that the bride only shows herself to unattached men. The legend goes that the ghost appears as a dreary lady wearing a wedding gown. Some reports say that she has been seen sitting at the edge of the woods. She has also been seen standing by a grave (it's not known if it's her grave) or walking in the nearby street. She is waiting for her fiancé to return and finish their elopement. He left her standing at the altar with no explanation. The doctor says she died of a broken heart.

OLD WHITMIRE HIGHWAY

Phantom figures on lonely, deserted highways in South Carolina are nothing unusual to ghost hunters. Old Whitmire Highway is no exception to the rule. The only difference is that Old Whitmire is haunted by a man and a dog. People traveling down this road have reported seeing a bright light in the distance. Thinking it may be a possible wreck or stalled vehicle, they slow down in order to pass safely. When they draw near to the light, there

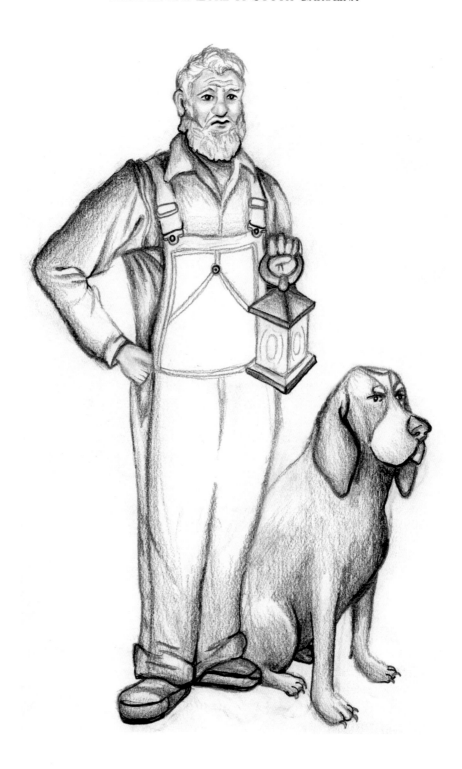

is no sign of an accident or a vehicle. They see two figures standing in the road just ahead. They are a semi-transparent and illuminated figure of a man carrying an old lantern and wearing an old shirt and bib overalls and a large brown dog sitting on the ground beside him. As the motorists pass, the ghostly figures watch. Instead of the spirits turning their heads to watch the motorists pass, it seems as if the entire surrounding scene is turning.

MADELINE

Some people believe that on Halloween, the distance between our world and the world of the afterlife become very small. This allows the restless spirits to enter our world. Some return to their world while others remain in ours. Like everything else in the world of the supernatural, there's no way to prove this theory. Is this a Halloween tale or fact? Halloween is a day to tell ghost stories and scare trick-or-treaters. Many ghost stories have evolved from Halloween tales while others, such as that of Madeline, have more natural beginnings.

After my first book, *Forgotten Tales of South Carolina*, hit the market, I received a call from Barbara Nuessle in Aiken, South Carolina, wanting to know if I had included Madeline in my book. More about that in a minute. Now for the story of Madeline.

Why does more than one ghost haunt a location? Newberry College is home to two ghosts. One ghost is said to haunt the upper floor of Kinard Hall dormitory. Students report faucets turning on and off by themselves and cabinet doors and drawers opening without any help. Windows suddenly open, and footsteps are often heard when no one else is around.

The most famous haunt in Newberry College is a beautiful young girl named Madeline. Madeline haunts the bell tower of Keller Hall. During the Civil War, Madeline jumped to her death from the bell tower. It was too much for her to take when she heard the news of her boyfriend being killed in battle. Over the years, there have been reports of a girl's scream heard in the area of the bell tower. There have been reports of actual sightings of a young girl in the bell tower. Another version of the story is that Madeline fell in love with a Union soldier when they were stationed at Newberry College during the Civil War. When the troops withdrew, Madeline could not go with them. Refusing to face the fact that her boyfriend was gone and she'd probably never see him again, Madeline wandered around the college

looking for him. In her grief, she killed herself by jumping from the bell tower. Some say she returns on Halloween night.

And now the rest of the story. The following stories are used with the permission of the original author, Barbara Nuessle. Here is the story that Barbara wrote in November 1959 when she was the editor of the college newspaper:

"Miss Madeline" Returns; Searches For John, Her Lover
It is over, at least for another year! On the night of November 17th "Miss Madeline" returned to the campus of Newberry College in search of her lover, John, who was killed here approximately fifty years ago. This is the first appearance that the one-time beautiful young lady from Newberry College has made in some time. For some years she has been in an institution in the northern section of the country and has been unable to make the visit to the campus on the anniversary of the death of her lover.

The tragic story goes that "Miss Madeline" and John were dating and considering very seriously getting married as soon as John completed his studies here at the college. "Miss Madeline," being the beautiful young lady that she was, sometimes slipped out on John and dated other young men. Rumors had circulated around, and John's roommate, feeling that John should know of "Miss Madeline's" undertakings, told him all that he had heard. John, not wanting to believe what he had been told, took a stroll around the campus to think things over. In his despair he climbed to the top of the tower in Keller Hall and jumped to his death.

At the very time of his jump "Miss Madeline" was on her way to Newberry College in her carriage to confess to John that she had betrayed him and that now she realized that she loved him and wanted to marry him as soon as possible.

Leaving her carriage on the street which is now Evans Street and proceeding up to Smeltzer Hall, which was the dorm for men at this time, she was destined to walk by Keller Hall. With only a small lantern for light, she could not see very well, and as fate would have it, she stumbled over John's body. When she saw what had made her stumble, and when she saw his broken body, "Miss Madeline" released a scream, which some former students say was heard throughout the campus exactly at midnight.

The Midlands

Here is the letter that Barbara Nuessle wrote to the editor in 1961:

After the 150th Anniversary edition of Dimensions *was released last fall, I received a letter from an alumna who was intrigued by the story of Madeline. She was pleased the story was being told, but wanted to share some information with me that was not divulged in the last issue.*
 Dear Cayce:
 I read with interest Dr. Epting's version of the legend of Madeline. Enclosed you will find the original story, which I wrote in 1959 when I was the editor of the college newspaper The Indian. *There was no Madeline legend before that time. If one checks the year books and college newspapers prior to November, 1959, he or she will find no mention of her. I wrote the story since I needed an additional feature article in the mid-November edition.*

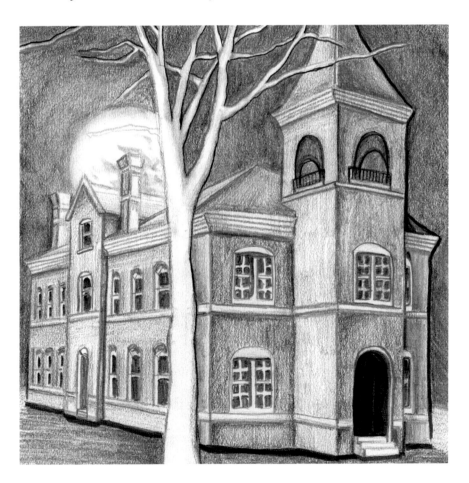

Madeline was born as I sat in Wessels Library, listening to the cold November wind blowing through the extremely tall pines near the library. What a chilling sound the wind made! At that time I knew that Columbia College had a ghost story. Listening to the eerie wind, I decided Newberry also needed a legend. Thus, Madeline was born.

The story was set at Keller Hall for its architecture had always fascinated me and at night looked ghostly. My steps would always hasten when I walked alone between Smeltzer and Keller on my way to Kinard. To me, that spot was not only the coldest place on campus but also a little frightening in the dark for a young college girl.

I selected the name Madeline since one of my best friends, Bobby Mood from Sumter, was dating a Columbia College student named Madeline McAlister. I addition, the name had a melodious sound, resembling some of Edgar A. Poe's word choices. Therefore, I named our lady Madeline.

Rodney Parrott, another dear college friend and later a Lutheran minister, interpreted the character for the first time. I still remember looking out my second-floor dorm window and seeing Rodney approaching Kinard Hall. He did a superb interpretation for her first appearance on campus and also made his second appearance as Madeline on November 17th 1960.

Some years ago I was very surprised to learn that Madeline still appeared at the college; however, I was disappointed that her appearance was tied to Halloween. In the version printed in Dimensions, *you all now have the correct date.*

Barbara Nuessle '61

THE THIRD EYE MAN

The first sighting of the Third Eye Man was on November 12, 1949, on the University of South Carolina's campus in Columbia. According to reports, a man dressed in bright silver clothing of some type was sighted opening a manhole cover opposite the Long Street Theatre at the corner of Sumter and Greene Streets. At approximately 10:43 p.m., two students watched this man enter the sewer.

Five months later, on April 7, 1950, the Third Eye Man was spotted again. A university police officer was on routine patrol and found mutilated chickens behind the Long Street Theatre. The officer returned to his patrol car and reported this to the station. The police officer then returned to the

location of the mutilated chickens. When he arrived at the scene, to his surprise, he saw a man dressed in bright silver clothes huddled down over the mutilated chicken parts. The policeman shined his flashlight on the man and caught him by surprise. When the man looked up into the beam of light, the officer could make out a face grotesque in shape and color. His skin was described as grayish in color. The policeman noticed that in the middle of the man's forehead was a small third eye. The officer returned to his car to call for additional policemen to back him up. When the officers arrived on the scene, the man was nowhere to be found. The first policeman was never able to convince the other policemen of what he had witnessed.

In the late 1960s, the underground tunnels at the University of South Carolina were a favorite place for students to explore. In early October of an unknown year, a group of fraternity boys decided to take several pledges down into the tunnels for an initiation. The group headed west. As they rounded the corner, a crippled-looking man dressed in bright silver met them. The man moved toward the students with a piece of pipe. The students, realizing that this was not a prank, began to run. The man knocked down one of the pledges. The student was not injured. The incident was reported to the police. After hours of an exhausting search, the police came up with no evidence of a man dressed in bright sliver clothes in the tunnels. However, the police did take precautions by sealing off the entrances to the tunnels.

There were several sightings of the Third Eye Man in the late 1980s and early 1990s. None was confirmed.

COLONEL ISAAC HAYNE

There are several different versions of the Isaac Hayne legend. One story says he was shot by firing squad; another says he was hanged. In 1781, Colonel Isaac Hayne was condemned to death by the British during the occupation of Charles Town. Hayne was probably the most prominent American to be executed during the American Revolution.

Following in his father's footsteps, Hayne was elected to represent St. Bartholomew's Parish. In 1770, Hayne was elected commissioner for issuing money to offset the cost of building courthouses and jails. In 1777, he was elected to the Second General Assembly for St. Paul's Parish. He declined to serve in this position. He was later elected to the Third General

Assembly. Hayne served in the Senate during 1779 and 1780 for the parish of St. Bartholomew.

At the time of the Revolutionary War, Hayne was enjoying a profitable life on his plantation. The Revolutionary War was soon to interrupt Hayne's peaceful life on his nine-hundred-acre plantation. In 1776, Hayne, a captain in the militia, headed to Charles Town with 160 privates and 13 officers. Hayne served in the Colleton County regiment of the militia and fought behind enemy lines. Hayne was not in Charles Town when it was surrendered.

There are several versions of the story of his capture and execution. The first is that he was in the backcountry when he was captured and taken to Charles Town. Another is that Hayne surrendered to avoid being captured or killed in an attempt to capture him. Hayne was held in the prison of the provost, in the basement of the Exchange Building. Lord Francis Rawdon and Nesbit Balfour issued a statement sentencing Hayne to death. Hayne, pleading for his life, asked for a respite that he might see his children for a last farewell. This was denied. At 1:00 a.m. on July 31, 1781, Hayne was told to prepare himself for death. Hayne was not allowed to see anyone after he was delivered the final message. Hayne would leave for his execution at 5:00 a.m. At the last minute, Hayne was granted a forty-eight-hour delay. Eyewitness accounts stated that Hayne was escorted by a group of soldiers to the awaiting gallows. As his footsteps drew him nearer and the crowd looked on, Hayne took his final steps up to the gallows. His hands were tied behind him, and he was hanged until dead.

Another account states that Hayne was convicted of treason against the King of England and sentenced to death. On the day of his execution, he was forced to walk by his aunt's house. His aunt and two sons were watching from above. As the two sons made their last farewell to their father, Hayne responded, "I will return home." Hayne was escorted by a group of soldiers to the location of the execution and put to death by firing squad. According to legend, the boys' souls still remain at the window calling to their father. Anyone standing at the window at dusk can hear Hayne's voice calling to his sons. Many times after nightfall, footsteps can be heard coming from the steps of the house. Has Hayne returned to his sons as he promised just minutes before his death?

AGNES OF GLASGOW

Agnes of Glasgow, a prominent woman of South Carolina folklore, was a real person (1760–1780). Agnes was born in Glasgow, Scotland, in 1760. During the American Revolution, her fiancé, Lieutenant Angus McPherson, a British officer, left her to come to America to fight. Distraught over losing her beloved, Agnes located a ship leaving England bound for America and stowed away. The long journey was rough, with very little food and water, but the determined Agnes would soon arrive in America. She arrived in Charleston believing that Lieutenant McPherson's unit may be located near Camden. She heard that he may have been wounded, and she endeavored to get to him as soon as possible.

She wandered through the wilderness and small settlements, receiving food and lodging from anyone willing to help. She was hoping to find someone who knew Lieutenant McPherson or where his group was located. She was befriended by Wateree American Indian Chief Haigler, who made her passage to the Camden area much easier. Her travels were in vain. She never found Lieutenant McPherson or anyone who knew him. With a broken heart, she became ill and died before they could be reunited. When she died, the Chief Haigler buried her under the cover of darkness. She was buried in the old Quaker Cemetery in Camden.

For over 225 years, the restless spirit of Agnes of Glasgow has haunted the old Quaker Cemetery. She wanders around the graveyard searching for her fiancé, but McPherson is nowhere to be found. Will Agnes ever reunite with her fiancé, or is she destined to wander around the old Quaker Cemetery forever?

The old Quaker Cemetery dates back to the earliest days of Camden. Camden was first settled in 1730 and is the oldest inland city in South Carolina and the fourth oldest city in South Carolina. There are a number of famous people buried in the old Quaker Cemetery. Here are a few of the notable ones:

AGNES OF GLASGOW (1760–1780)

JOSEPH BREVARD KERSHAW (1822–1894), Confederate army general and later a member of the United States Congress. Kershaw County was named after his ancestors.

JOHN PETER RICHARDSON III (1829–1899), governor of South Carolina (1886–90)

JOHN BORDENAVE VILLEPIGUE (1830–1862), Confederate army general

JOHN DOBY KENNEDY (1840–1896), Confederate army general and later a South Carolina lieutenant governor

RICHARD ROWLAND KIRKLAND (1843–1863), Civil War soldier and hero at the Battle of Fredericksburg. Kirkland was known as the "Angel of Marye's Heights" because he gave water to dying Union soldiers.

BADWELL CEMETERY

Not a lot of mystery surrounds Badwell Cemetery, but it's still well worth telling the story. To get to Badwell Cemetery, follow South Carolina Scenic Highway 28 north out of McCormick to the Sumter National Forest in McCormick County. Just outside McCormick is a marker that tells the story of Badwell Cemetery. The cemetery has been around for over two hundred years. It is the final resting place for the French Huguenot settlers. Notables buried there include Reverend Gene Louis Gilbert, leader of the 1764 settlement of French Huguenots at New Bordeaux. Many other prominent people are also laid to rest there.

For many years, the cemetery lay forgotten by time and people. Vandalism took its toll. After being vandalized and neglected for many years, Badwell Cemetery fell into a state of disrepair. The United States Forest Service acquired Badwell Cemetery in a land exchange with the United States Army Corps of Engineers in the 1970s.

In the 1990s, vandals knocked down, broke and took parts of many of the monuments and headstones in the cemetery. The famous cast-iron Grim Reaper, dating back to the 1860s, was stolen from the cemetery gate. Parts of the granite wall that surrounded the cemetery were so severely damaged that it fell to the ground.

The United States Forest Service, local partners, many volunteers and professional restoration experts recently refurbished several areas of the cemetery, including many grave markers, part of the fallen wall and the famous iron gate. Although in many pieces, the Grim Reaper was eventually recovered. Badwell Cemetery features many distinctive nineteenth-century design elements and grave monuments. Restoration continues.

When doing research on Badwell Cemetery, I came across a short blip about numerous sightings of a troll walking around the wall of the cemetery.

FORTY-ACRE ROCK

Forty-Acre Rock, located in Lancaster County, is designated as a national natural landmark. It is located where the Sandhills meet the Piedmont. It is not 40 acres, as the name implies; it is actually 14 acres. The entire Forty-Acre Rock Heritage Preserve is 2,267 acres. The preserve includes granitic flat rocks, waterslides, waterfalls, a beaver pond, caves, hardwood and pine forests and a variety of wildflowers and wildlife. There are twelve endangered species of plants in the preserve, the pool spirit being the rarest.

Millions of years ago, a magma intrusion formed this rock formation. Rare wildflowers grow in abundance in pools created in sunk-in places on the rock. A good time to visit Forty-Acre Rock is in late March, when the wildflowers provide the main landscape color. Fall is another excellent time to visit, when the leaves start turning to a brilliant hue of colors and time slowly fades into winter.

When visiting Forty-Acre Rock, listen for the songs of such birds as tanagers, warblers and many other songbirds. Take time out and listen for the steady drumbeat of the woodpecker. Other animals that can be found in the preserve are whitetail deer, turkeys, beavers, foxes, bobcats and the mythical black panther, which nobody wants to admit exists in South Carolina. Watch your step for timber rattlers as you're walking through the preserve.

There are several strange stories about the devil associated with Forty-Acre Rock. The outcrop has a lot of indentions in it that people call the devil's footprints. The legend tells how the devil sat down on the rock to rest and look for his next soul and left his mark. There are also marks on the rock that people say the devil made by dragging his chains.

Forty-Acre Rock has been desecrated by vandals spray painting the rock and riding four-wheelers through the delicate fauna. Cave walls have also been spray painted with graffiti.

THE JACK-O'-LANTERN GHOST

Rumors of buried treasure in South Carolina date back to the days of pirates, who buried their treasure along the coast in order to keep other pirates from getting it. During the Revolutionary War and the Civil War, people buried their treasure to keep the other side from getting it.

Many people had their own way of protecting their treasure. The jack-o'-lantern ghost was one of the many ways. Many old-time residents of South Carolina still believe in the jack-o'-lantern ghost. The legend is falling by the way because many people don't believe in buried treasure or even ghosts anymore.

I have not been able to locate the origin of this legend. The only source I've found is several posts on the Internet. Whether it's true or just a campfire tale, it's still interesting. In the old days when someone buried their treasure, it didn't have to be silver, gold or jewels. It could be anything of value or sentimental value that they wanted to keep safe. They would find a tree with a unique character about it that they could remember and bury their treasure underneath it. Next, they would kill an animal and bury it on top of the treasure. They would sit a jack-o'-lantern on the ground above the treasure. The ghost of the animal would haunt the spot where it was buried

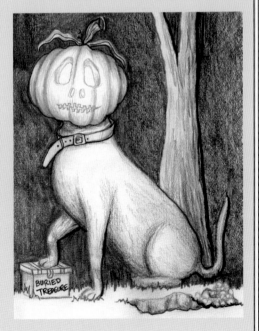

and take up residence in the jack-o'-lantern, thus producing the jack-o'-lantern ghost. It has been told that from a distance you can see small lights in the jack-o'-lantern, maybe the dead animal's eyes. The jack-o'-lantern ghost floats over the buried treasure in some very unusual ways. Those who have reported seeing the jack-o'-lantern ghost say it's impossible to get close to it. When you try to approach it, it simply floats away or will vanish. Maybe the animal is not protecting the treasure; maybe it is returning to haunt the person who killed it.

THE PEE DEE

THE GEORGETOWN LIGHTHOUSE

The Georgetown Lighthouse, also known as the North Island lighthouse, stands eighty-seven feet high. At a latitude N33 13.40, longitude W79 11.10, it is South Carolina's oldest active lighthouse. Since 1986, the light has remained on both day and night. The lighthouse is located on North Island on the northern side of the entrance to Winyah Bay. The lighthouse is located about twelve and a half miles from Georgetown, South Carolina.

As early as 1726, the members of Prince George Parish petitioned for the establishment of an official port at Winyah Bay. Georgetown was established in 1732. It is the third oldest port in South Carolina. At one time, Georgetown exported more rice than any other port in the world. As business at the Georgetown port increased, there became a need for a lighthouse to guide the merchant ships safely into the harbor and get them safely past the peninsula between the Waccamaw River and the Atlantic Ocean

In 1789 a wealthy businessman, Paul Trapier, donated a piece of land for the lighthouse. In 1790, the federal government took over responsibility for all navigational aids. Due to politics, it was several years before Georgetown finally got its much-needed lighthouse. On February 28, 1795, the government bought a piece of land and released $5,000 for the construction of the lighthouse tower. More politics delayed construction until 1799. After two years of construction, the lighthouse was finally lit. The first tower was constructed with cypress wood for durability. It

measured seventy-two feet high, and the tower base measured twenty-six feet across. The lantern was six feet in diameter. The beacon was fueled by whale oil.

Weather could not be predicted accurately in those days, and furious storms would hit North Island unexpectedly with hurricane-force winds and pounding rain. The lighthouse survived only five years before the island was hit by a fierce storm that struck suddenly and, with devastating force, destroying the lighthouse. In 1812, a new and more modern lighthouse was built. The tower was constructed with bricks and painted white. It also stood seventy-two feet high.

During the Civil War, Confederate soldiers used the lighthouse as an observation post until it was captured by the Union army in May 1862. The lighthouse sustained heavy damage during the Civil War. Due to the extensive damage, it was rebuilt in 1867. The brick tower stands eighty-seven feet tall; the base is twenty feet in diameter. The walls are six inches thick. Several other buildings are located on the lighthouse property: the oil house, a cistern and a two-story house that served as the lighthouse keeper's residence.

The lighthouse was manned by the U.S. Coast Guard until 1986, when it was automated. The lighthouse is equipped with a 3500-candlepower light that is magnified through a fifth-order Fresnel lens. The light is visible over twenty miles away. The Georgetown Lighthouse is one of the oldest in the Southeast and is listed on the National Register of Historic Places. It lives on as a monument to maritime history.

ANNIE OF THE LIGHTHOUSE

The lighthouse built on North Island included living quarters for the light keeper and his daughter, Annie. Annie took part in the day-to-day operation and upkeep of the lighthouse. Annie was in charge of maintaining their living quarters and preparing their meals.

One day, with supplies running low, Annie and her father rowed across Winyah Bay to the port of Georgetown. They always scheduled their trips with the tides to make sure they had enough time to get back to the lighthouse to light the lantern. Halfway through their trip, a strong wind came up from nowhere, and giant waves covered the boat. As the boat began to sink, the lighthouse keeper tied Annie to his back. With

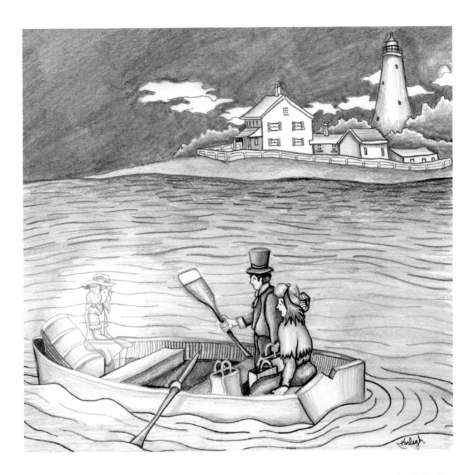

nothing left to do, he tried to brave the treacherous waters. With the wind blowing and the waves pounding his every move, exhaustion finally won the battle. The lighthouse keeper woke up on the shore. Annie, still tied to his back, had drowned.

Since the day of that tragic ending, many seafaring people have reported a young child suddenly appearing on the bows of their boats. This usually occurs on calm days. The young child is always pointing to the bay as if begging to return. This ghostly visit occurs just before an unexpected violent storm. As the legend of Annie goes, those who refuse to heed her warning will end up in a watery grave.

THE DISAPPEARANCE OF THEODOSIA

There are many mysteries surrounding Theodosia Burr Alston's disappearance. Theodosia decided to meet her father, Aaron Burr, in New York City in 1812. December 30, 1812, was a cold winter morning when Theodosia set sail from Georgetown, South Carolina. She boarded the *Patriot*, a schooner that was used as a privateer during the War of 1812. The sails were full as she left Georgetown behind. Her ship was suddenly engulfed in a thick fog, never to be seen again.

Theodosia Burr was born on June 21, 1783. The exact date of her death is unknown. Theodosia was the daughter of Theodosia Bartow Prevost and United States vice president Aaron Burr. Theodosia was born in Albany, New York, but lived mostly in New York City. When Theodosia was eleven, her mother died. Aaron Burr would supervise his daughter's education. Theodosia was given an education that at that time was only afforded to boys. She studied French, music, dancing, arithmetic, Latin, Greek and philosophy.

At age fourteen, Theodosia began to serve as the hostess at Richmond Hill, Aaron Burr's home in what is now known as Greenwich Village. Theodosia was very beautiful and very intelligent, and many wealthy young suitors attended the dinners and parties held at Aaron Burr's New York estate. On February 2, 1801, Theodosia married Joseph Alston, a wealthy landowner and politician from South Carolina. The happy couple honeymooned at Niagara Falls, the first recorded couple to do so. Alston was governor of South Carolina and owned a large rice plantation. The marriage meant that Theodosia would become one of the most prominent people in the South Carolina social circles.

Theodosia and Joseph had a son, Aaron Burr Alston, born in 1802. Each summer, the Alston family would move to the Castle on DeBordieu Beach to escape the deadly malaria fever. In the summer of 1812, they moved to the Castle as usual, but ten-year-old Aaron was already sick. The doctors could do nothing for him, and he died at the Castle before the end of June. They returned to the Oaks, their plantation, for the burial in the family cemetery.

Theodosia's health was never good in South Carolina; the heat and humidity often left her sick. Coupled with the loss of her son, Theodosia never seemed to recover. Her health kept going down. Finally, as a last resort, all agreed that a visit to her father in New York might be just the medicine she needed. Preparations were made for the trip to New York. Theodosia

and her party boarded the boat at Georgetown and set sail. The captain, William Overstocks, wanted to make a fast run to New York with his cargo. The *Patriot*'s guns had been taken down and stored below deck. The *Patriot* had no defense if it was attacked.

Due to the War of 1812, any sea travel became risky. Fortunately, Governor Alston's influence was able to procure letters of safe passage for Theodosia to the American and British ships. This would be the last time anyone would see the *Patriot*, Theodosia or any of the crew again. What happened to the *Patriot* and Theodosia remains a mystery to this day.

There are many theories about the disappearance of Theodosia and the *Patriot*. One is that they were captured by pirates and all passengers were killed. Another story from Alexandria, Virginia, is that Theodosia may have been the mysterious female who died at Gadsby's Tavern on October 14, 1816. Another story is that the *Patriot* was wrecked off Cape Hatteras, North Carolina, by a storm. Logbooks from the ships of the British fleet in that area reported a severe storm that began off the coast of Cape Hatteras in the afternoon of January 2, 1813. Another story is about an Indian chief who found a white woman chained on a wrecked ship. She gave him a locket with "Theodosia" engraved on it. Minutes later, she died in the chief's arms.

What happened to Theodosia will always remain a mystery. Whatever happened, many people believe that the uneasy spirit of Theodosia still haunts the South Carolina Lowcountry. Some reports say people have seen the wandering spirit of Theodosia in front of the old warehouse in Georgetown where she boarded the boat. Other reports have seen her walking along DeBordieu Beach. Some have seen her floating over the waves at Huntington Beach, while others have seen her walking the paths and down the steps at Brookgreen Gardens. Is Theodosia's ghost destined to roam the Georgetown area forever, or will she one day find her way home?

WEDGEFIELD PLANTATION

The early 1700s saw the waterways and coastal region of Georgetown County attract many people, including rice planters. Wedgefield Plantation goes back to South Carolina's colonial period, when Georgetown was first settled by the Europeans. The area now known as Wedgefield Plantation was included in one of the first land grants. The plantation was in operation before 1750. Wedgefield became a separate plantation in 1762, when John

Waties sold part of his land to Samuel Wragg. Wragg was a planter, merchant and political figure in pre-Revolutionary South Carolina.

The first house built on the property was a small one-and-a-half-story cottage. Wragg had a second home built on Wedgefield Plantation to entertain business and political people from other colonies. It was a large two-and-a-half-story building with a separate kitchen. After the second house was built, the cottage was used for the plantation overseer's house.

When the American colonies declared war for independence from Great Britain, Wragg remained neutral. Most of Wragg's business dealing was with England, and he didn't want to ruin his contacts. Most of Wragg's family was engaged in the Revolutionary movement. Wragg, being caught between a rock and a hard place, had to support both sides until the British soldiers marched into Georgetown. Wragg then supported the British. Wragg's daughter supported the colonies and became one of General Francis Marion's best spies. She would receive and deliver letters containing information to and from the Prince George Church cemetery, which adjoined the plantation.

Wedgefield Plantation was converted into a hospital for wounded soldiers and a place where prisoners were held. Francis Marion devised a plan to rescue the American prisoners. The soldiers at Wedgefield were invited to a supper at Mansfield Plantation. They left one soldier to guard the prisoners at Wedgefield Plantation. As Marion's men rode up to the home, the lone soldier ran out of the house. Realizing that it was Marion's men, he drew his pistol and fired one shot. Before he could reload and get off another shot, one of Marion's soldiers swung his sword, and the soldier's head fell to the ground, leaving the headless body standing there. The body slowly crumpled to the ground in a pool of blood. The soldier was buried on Wedgefield Plantation.

The plantation stayed in the family after Wragg died in 1787. Wragg's son kept the plantation until 1840. Wedgefield passed through several other owners. In 1888, Wedgefield was sold to the descendants of the original colonial family the Hazzards. The Hazzards had roots in Beaufort, South Carolina.

In 1838, a border dispute between a Hazzard and an aristocratic rice planter ended in the slaying of the rice planter. There was no conviction for the slaying of the rice planter. After the Civil War, the three Hazzard brothers traveled to Georgetown to purchase more land. They bought Esterville Plantation, Beneventum Plantation and Keithfield Plantation. In 1888, they pledged Wedgefield as their sister's dowry in marriage to Charlestonian

William H. Holmes. In 1909, the Hazzard family left Wedgefield due to the failing rice market in South Carolina.

A Vanderbilt heir, Robert Goelet, from Newport, Rhode Island, bought the plantation and built the Georgian Regency Manor Home. In 1946, Goelet sold Wedgefield, and it sold again in 1950 to John Hazzard III, who kept it for the next twenty years. In 1970, Wedgefield was bought for the development of a residential and country club–oriented subdivision.

Wedgefield Plantation has its resident ghost. For generations after the beheading of the soldier, people have reported seeing the ghost of the unfortunate soldier wandering around the outside of the plantation home. Sometimes before the headless spirit is seen, the sound of distant horses can be heard. This usually happens just before night. When the horses go silent, the form of a headless eighteenth-century British soldier can be seen holding a pistol and staggering around the yard. The apparition vanishes as quickly as it appears. Others have reported seeing the headless ghost late at night, especially on moonlit nights, walking back and forth on the porch as if he is still guarding the prisoners.

During the 1930s, the old house was torn down and replaced by the present home. The ghost of the headless soldier has not been seen as often. Reports of strange noises are still heard in the house.

THE DAISY BANK GHOSTS

During the early part of the nineteenth century, Daisy Bank was a thriving southern plantation. Today, it is almost forgotten.

A cheerful name and a few old stories that follow southern plantations are all that is left. According to the stories, a young sea captain and a rice planter's daughter met and immediately fell in love. They wanted to get married, but the sea captain didn't fit into the social circle of the daughter of a wealthy plantation owner. The young girl was known throughout the area for her exquisite beauty. Many of the young men from neighboring plantations tried to court this southern beauty, but her heart was with the sea captain. The family wanted their daughter to marry into a family from another plantation so she could keep her social standing. When the captain found out that her parents objected to their marriage because of him being a seafaring man, he decided that the young girl was more important to him than his life at sea. He gave up the sea and bought Daisy Bank rice plantation. He settled down

to the life of a rice planter. He built an elegant home on the plantation for his future bride. After the house was completed, they were married. She quickly moved into the house and became the mistress of Daisy Bank. Their home soon became the social center of the area, with parties, dinners, all-night dances and many other social events. There were few days when the house wasn't filled with guests. Her life was perfect—but it would be short-lived.

They celebrated their first anniversary with a dinner party, and guests from all around were invited. About halfway through the party, the couple made an announcement: there would be another issue to the family. Congratulations and toasts were being made to the happy family, and laughter and excitement filled the air. It was a joyous occasion for everyone. None realized that the happy occasion would be short-lived.

Time passed, and the baby came. In less than a day, the baby died. A few hours later, the mother died. Gloom and sadness came over Daisy Bank. The house that was once filled with parties and laughter was now cold and lonely. Happiness on Daisy Bank was no more.

The captain was beside himself with grief over the loss of his beloved wife and child. He had his wife dressed in her wedding gown with a rose placed delicately in her hair. He had her placed on the couch in their home, with one arm placed around the baby lying on her chest. The captain remained beside the couch both day and night. After two days of constant vigil, the captain made arrangements for the funeral. He summoned the coffin maker from Georgetown to the plantation. The captain gave the coffin maker specific instructions on how the coffin was to be built, with a form-fitting inside with silk and ruffles. The outside was to be made of highly polished walnut. No lid was to be put on the coffin. He instructed the coffin maker to place the open coffin in a heavy iron vault. The vault was to be covered with a sheet of thick glass. Molten lead was to be used to seal the cracks and make sure it was airtight.

For several months, the captain kept the vault in the house. Finally, his sanity returned, and with some persuasion from family members, he decided to give his wife and child a Christian burial. After the funeral, the iron vault was placed in a brick tomb that had been built in a sunny spot between two trees. A hole had been left in the brick tomb so he could see the faces of his beloved wife and child. He had a removable metal plate made to fit over the hole in the tomb so it could be opened or closed. Behind the vault, he built a trellis and planted his wife's favorite rose.

After the captain's death, no one was left to care for the plantation or the grave. The trellis rotted and fell to the ground, but the rose continued

to grow, climbing the trees that were on each side of the tomb. As the years passed without proper care, the grave site fell into ruin, the once sweet smell of the exotic rose faded and the rosebush turned into nothing more than a briar rose.

In the 1920s, many plantations were forsaken and left in ruins. People from different parts of the country would come down and buy or lease these forgotten plantations for hunting purposes. Daisy Bank was no exception. A rich northerner bought the adjoining plantation and leased Daisy Bank for hunting. It was used only during hunting season. The son of the man who leased Daisy Bank was in his early twenties. He made friends quickly, and in particular, a young girl from a neighboring plantation caught his fancy. One day, the young man decided to have a deer drive. It was to last all day, followed by a big party on the plantation. The hunt was to cover several plantations, and Daisy Bank was one of them. This hunt was for doubles, meaning the man could bring his wife or girlfriend. The hunters were placed in couples at different locations on the plantations. The dog drivers would run the dogs through the woods until they located a deer. Then the dog would run the deer by the hunters.

The owner's son and his lady friend were placed in the graveyard on Daisy Bank. After hours of standing, they became tired. While searching for

a place to sit, they found the tomb. He took out his hunting knife and began to cut away the briars and vines that had covered the tomb over the years. Some of the vines had grown under the metal plate, and as he pulled them away, the metal plate fell to the ground. He looked into the opening and quickly backed away in horror. He called his lady friend over to see what was in the tomb. When she looked into the opening, she screamed and stumbled back, almost falling. Both eased up to the opening to get a better look. Inside, they saw a girl and her baby still in good condition after all these years. As they sat there talking, the girl remarked on what a beautiful bracelet the corpse was wearing. It

was the most beautiful bracelet that she had ever seen. With this thought, the boy took the stock of his gun and smashed the glass that was covering the two bodies. When the air hit the bodies, they disintegrated, leaving only skeletons. The boy reached in, removed the bracelet from the skeleton's arm and handed it to his girl. She was horror stricken by what he had done, but since he had already done it, she took the bracelet. Unhappy about what had just happened, they left the hunt and returned home.

People have reported seeing a young girl with a baby walking around the tomb. Have the girl and her baby returned from the hereafter in search of her stolen bracelet? There have also been reports of her husband sitting by the grave site. Is he still watching over his wife and child?

Some years ago, a man requested permission to move the coffin and remains to a proper graveyard. Permission was granted, and they had a proper burial in the Christ Church Cemetery. Daisy Bank has since been incorporated into Annandale.

LITTLE RIVER BIGFOOT

On Monday, April 30, 2007, in Little River, a Bigfoot sighting occurred. A Little River resident was walking along a wooded area of Highway 17 at about 9:00 p.m. As he passed by a small creek, he heard something moving in the bushes near the creek. As he walked on to the store, which was about another ten minutes away, he could still hear the noise but could not see anything. On his return trip home, he passed by the same area. As he approached, he heard a louder noise in the bushes. He continued to walk and could hear footsteps in the bushes. When he stopped, the footsteps would stop. As he would start to walk again, the footsteps would start again. The footsteps moved ahead of him and disappeared in the distance. As he approached a business with outside lights, he saw at the edge of the woods a large, dark creature squatting down near a trash container.

SAMPIT BIGFOOT

The Sampit community near Georgetown has a population of about eighty-five. On Wednesday, May 13, 1998, around 11:50 p.m., a

motorist was driving north near Sampit on Highway 521 heading toward Columbia. Around 12:00 a.m., the motorist saw something like a small animal running along the side of the highway. The small animal dashed across the highway in front of the car. When illuminated by the car's headlights, it appeared to be a fox. As it crossed to the other side of the highway, it disappeared into the woods. Seconds after the small animal disappeared, a large, dark, shaggy creature about seven feet tall crossed the highway in front of the car. The creature ran on two feet and crossed the highway in several long steps. The creature was not moving very fast, and the car had to slow down in order to miss hitting the humanoid creature. It disappeared just beyond where the small animal had entered the woods.

HEMINGWAY

In 1743, the King of England granted land to a group of Scots-Irish settlers who had traveled down Black River in search of a new life. The area they settled in is now known as Williamsburg County. In 1880, B.G. Lambert owned a large amount of land in the northeastern part of what is now Williamsburg County. He owned and operated a general store where Stagecoach Road and Kingstree Road came together. In 1900, a post office was established in Lambert's general store, and the community became known as Lamberts.

The Hemingway family began to move into the area and acquire land. Soon, the Hemingways took over as the major landowners. In the early 1900s, Dr. W.C. Hemingway sold part of his land to the Seaboard Airline Railroad, which came through Lamberts and built a depot. The railroad connected Lamberts to other areas too far away for local people to travel to. With the establishment of the Seaboard Airline Railroad, businesses began moving into the area, and Lamberts began to grow. Lamberts became a market center for cotton and tobacco. Cotton declined after 1921, when the boll weevil arrived in the area. At that time, cotton was being replaced by flue-cured tobacco by many farmers in the area.

On February 18, 1914, a petition for the charter for the town was filed with the secretary of state. On June 22, 1914, the town received its charter. The new town was named Hemingway in honor of Dr. W.C. Hemingway, as his guidance led to the development of the town.

General Francis "Swamp Fox" Marion traveled through Hemingway on his way to what is now Johnsonville during the Revolutionary War.

Hemingway is home to one of the few remaining interdenominational campgrounds. The Hemingway Campground was founded on April 17, 1961. The land for the campground was donated by Grace Lewis and her son Olin. It is located just west of Hemingway on Campground Road.

Agriculture and the manufacture of textiles were important parts of Hemingway. Textile plants and many stores have closed. Many people have had to go out of town to get jobs. There are a few businesses that have been there as long as I can remember, such as Quinton Hughes Barber Shop, Eaddy Brothers Service Station, Tomlinson's clothing store, Johnny Tanner's Service Station, Haselden Brothers car dealership, King and Queen clothing store and the Western Auto. Some businesses have fallen by the way, including the Anderson Theatre, Bryant Clinic, Dr. Ulmer's office, 5-and-10 cent store (known as the Dime Store), Richardson's Grocery, Joe McAlister's Grocery, Piggly Wiggly, Red and White and Morris Shoe Shop. I spent many happy Saturday evenings in the Anderson Theatre watching the cowboy shows. You could get in then for a quarter.

In the spring of each year, Hemingway hosts the South Carolina Barbecue Shag Festival. Hemingway has been home to the festival for the past twenty-two years.

As of the 2000 census, there were 573 people, 259 households and 182 families living in the town. By July 2009, the population had decreased to 483 people. In 2010, it was estimated that 580 people lived in the town of Hemingway.

THE HUMPBACK MAN

When you live on a farm in South Carolina, almost anything can happen—foxes in the chicken coop, chicken snakes in the henhouse, even an occasional creature from the woods sneaking into the house.

Pleasant Hill is a small farming community in Georgetown County. One day on this farm was going to be anything but normal. Late in the evening, when the sun was sinking low and the sky was covered with pastel colors that looked like they had been painted with the brush strokes of the master's hand, a young boy was going to get a frightening experience. He was going out into the pasture to separate the mother

cow from her calf for the night. His dog, as always, was following right behind him. The dog started barking and nervously moving around. It was looking over at the corner of the pasture. When the boy turned around and looked in the same direction as the dog, he saw a man—or what appeared to be a man—standing over by the woods. The man was about four and a half feet tall, humpbacked and slightly bent forward. His hair was down to his feet, and his beard was almost as long. The old man, wrinkled and bent with age, was holding a crooked walking stick. The man took a few steps toward the boy and his dog and then stopped. The boy and his dog ran back to the house. Arriving at the house, the boy told his father what he had seen in the pasture. The man got his gun and they went back to the pasture, but the old man was gone. All they saw was a rabbit; no human footprints were found.

Brown's Ferry Midget Man

In the late 1820s, the midget man began his journey from Georgetown to meet his true love miles outside the city. The midget man had been outcast because of his disability, but that did not stop him from making his way to the location where they had arranged to meet. The midget man traveled down a long dirt road known as Amos Road and finally reached his destination. When he arrived, he found his true love hanging from a tree, gasping her last breath. She was being punished for performing witchcraft experiments. He was unable to reach her, as the Grim Reaper held her in his death grip. After seeing his true love breathe her last and knowing there was nothing he could do to save her, the midget man lost his mind. He wandered aimlessly around the woods until his death.

Witnesses say that when you're traveling down Amos Road, you can identify the tree because of the green grass growing around the tree, watered by the tears of the midget man. Some reports say you can walk around the tree, reach up to rescue the lady and see the faint, ghostly image of the midget man in the woods waiting for you to release her. Reports of other unusual experiences include hearing a man crying in the distance or the hanging girl gasp her last breath.

Brown's Ferry Boat

The Brown's Ferry boat was discovered in 1971 by Hampton Shuping, a dive instructor who was diving in Black River. Hampton is licensed by the Institute of Archaeology and Anthropology at the University of South Carolina to recover underwater artifacts. In the summer of 1976, divers raised the remains of the small merchant vessel from Black River at Brown's Ferry in Georgetown County.

The boat is the remains of an eighteenth-century vessel. The Brown's Ferry boat was designed for hauling cargo but was able to navigate rivers and coastal waters. It was carrying twelve thousands bricks when it sank. Other artifacts found in the sunken boat were a beer mug with the arms of George II (1727–1760), four millstones, twenty-four bottles, three iron pots, a slipware cup, a straight razor and several smoking pipes, coins and china. The most interesting of all artifacts found was a quadrant, a deep-sea navigating instrument.

The discovery of this boat is being called the most important single nautical discovery in the United States today. Richard Steffy, a nautical archaeologist, reported that this discovery is evidence of American shipbuilders nearly fifty years earlier than previous discoveries. Artifacts located in and around the hull of the boat were dated to about 1740.

After sixteen years of restoration, the Brown's Ferry boat was moved to its current home. It is now located on the third floor of the Rice Museum in Georgetown. The roof of the Rice Museum had to be lifted off in order to place the boat inside the building. It was placed on exhibit in 1992. The Brown's Ferry boat is the oldest boat on exhibit in the United States. It was listed in the National Register on May 18, 1979.

Salem Black River Church

Salem Black River Presbyterian Church is known throughout the area as Brick Church. The picturesque building, of Greek Revival architecture, stands as a reminder of the rich history of South Carolina's religious past. The church was established in 1759 near what is today Mayesville in Sumter County. The land was given by Captain David Anderson. The church was founded by a group of Scots-Irish settlers.

In 1768, the original log meetinghouse was replaced by a more modern frame building. After the new building was complete, the name was changed to Salem Presbyterian Church. With the old frame building beginning to show signs of decay, a new building was planned by the church's congregation

In 1802, the first brick building was built and stayed in use until 1846. In that year, a new and more modern church was planned. The new church was built with bricks that were made on the church grounds. That church is still in use today. For over 160 years, this architectural marvel has stood the test of time. It has endured natural disasters such as the 1886 Charleston earthquake and the fury of Hurricane Hugo in 1989. After enduring these major disasters, Salem Black River Church still stands in serene testimony to the Scots-Irish settlers who braved their way to make a home in the wilderness land.

Land for the cemetery was deeded by Robert Witherspoon in 1830. The old session house in back of the church contains a large library that was donated by James McBride in 1862.

THE SOUTHERN BELLE GHOST

Not much information could be found on the Southern Belle Ghost, but the cemetery at the Brick Church (formally known as Salem Black River Church) is home to her. There are several different stories about this graveyard. One story is that you can see a small dark figure near the cedar tree by the path. Some visitors to the graveyard have reported seeing some of the graves give off a strange whitish-blue glow.

Another report is of a strange woman wearing a white dress moving, almost floating toward the visitor. The spirit of the woman smiled at the visitor as she moved closer to her. She was very beautiful with dark hair, but very pale. The spirit reached out and touched her hand. The spirit's hand was very cold. This spirit is believed to be the ghost of the Southern Belle.

COLONEL KOLB'S TOMB

Widely recognized as one of General Francis Marion's most able and reliable officers, Lieutenant Colonel Abel Kolb was a prominent Revolutionary War

Patriot in this area. Kolb had a plantation joining the Great Pee Dee River in the Sand Hills area of north central South Carolina. In 1781, under the cover of darkness, about fifty Tories silently made their way to Colonel Kolb's house. Their intentions were to surprise the colonel since they knew he was at home with his family. As the Tories silently approached the Kolb house, they came upon two of Colonel Kolb's officers and killed them.

Captain Joseph Jones, the Tory commander, approached the house with the other Tories a short distance behind him. He knocked on the door, and Kolb's wife answered. Captain Jones demanded that Mrs. Kolb have her husband meet him on the porch. Captain Jones assured Mrs. Kolb that no harm would come to her husband if he complied. If the colonel failed to come outside, Jones would burn the home to the ground.

Mrs. Kolb went inside and got her husband. She walked outside with him. As they stepped out on the porch, one of the soldiers fired a shot, hitting Colonel Kolb in the heart. Colonel Kolb fell to the ground clutched in his wife's arms. No one knows if the Tory had orders to fire on Colonel Kolb or not. Immediately following the death of Colonel Kolb, the Tories set the home on fire. One account says that Colonel Kolb and his family were burned alive when the Tories burned the house.

Colonel Kolb's grave is in the old Welsh Neck cemetery about one mile north of his homesite. The cemetery is located on the banks of the Great Pee Dee River and is now abandoned. Under a stand of trees is Colonel Kolb's grave, one of the few remaining graves that can be identified. If you're in the graveyard, you might hear footsteps in the nearby woods or see Colonel Kolb's ghost standing beside his grave.

THE CHURCH OF THE HOLY CROSS

In 1770, the legislature approved a chapel of ease near the now-extinct town of Manchester so the people from the High Hills area would not have to travel so far to attend church. In 1788, the chapel of ease congregation applied for a charter for the church. The charter was granted, and the Episcopal Church of Claremont was incorporated.

The land on which the church was built was donated by General Thomas Sumter and is located in Statesburg, just outside of Sumter. The building was constructed out of wood and measured thirty-seven feet high, fifteen feet long and seventeen feet wide. The church needed to raise money to pay

for the building, so the pews were auctioned off to the highest bidder. The pews were valued by their location in the church. The successful bidder was given a deed to his or her pew.

In 1849, in need of a bigger and better church, the congregation of the Episcopal Church of Claremont decided to build a new church. Its charter was amended, and the new church would be named the Church of the Holy Cross. A building committee was formed, with Dr. Anderson as the chairman. Anderson would use the same construction method in building the church that he used in his house, a method called rammed earth (pise de terre). Rammed earth is achieved by pouring clay into wooden molds and allowing it to harden. Layers are added until the wall is the desired height. When the walls are finished, they are covered with stucco. This type of building is almost impervious to earthquakes. With this unique style of building, the church has stood for over 150 years. The Church of the Holy Cross has survived the test of time and mother nature. It has survived earthquakes, tornadoes and hurricanes. The walls of the church are thirteen inches thick and forty feet high in some places.

The Church of the Holy cross is a shining example of the Victorian High Gothic Revival style of architectural design and furnishings. French architect Eugene Viollet-le-Duc designed the east and west stained-glass windows. The organ was constructed by the renowned nineteenth-century organ maker Henry Erben. It was installed in the church in 1851 and is still in use. It is one of the few Erben organs in existence in the United States today. The bell in the bell tower was installed in 1956. It is one of the few bells in the United States to be named. The bell was cast in Holland and given in honor of Mary Virginia Saunders White. The name "Mary Virginia" is cast into the bell.

Joel Roberts Poinsett was buried in the church cemetery in 1851. The Christmas poinsettia is named after him. Poinsett brought the flower from Mexico and introduced it to America.

The Church of the Holy Cross was declared a National Landmark in 1978.

FREEDA A. WYLEY

The *Freeda A. Wyley* was a three-masted barkentine ship built in Thomaston, Maine, in 1880. It was 156 feet long and weighed 507 tons. It was

carrying a load of yellow pine lumber to be delivered to New York when it encountered a great storm. On August 28, 1893, the *Freeda A. Wyley* was lost in the great storm. The hurricane destroyed many ships and took many lives. It is believed that the *Freeda A. Wyley* was struck by lightning during the fierce hurricane. The ship caught fire and burned to the waterline. The crew survived the fierce storm and was rescued. No lives were lost on the *Freeda A. Wyley*.

The heavy wooden hull drifted onto the beach at what is now Forty-third Avenue North in Myrtle Beach at high tide and got stuck. The remains of the *Freeda A. Wyley* were visible on Forty-third Avenue for over a century. The remains are no longer visible because of the city's beach renourishment project in the 1990s. What's left of the *Freeda A. Wyley* now lies covered with sand, but one day mother nature may decide to uncover the lost ship again. I had the pleasure of seeing the remains of the *Freeda A. Wyley* many years ago.

MANCHESTER

Manchester was established in 1790 as a stage stop and way station. Later it grew into an important cotton-shipping center for boats heading to or coming back from Charleston. The country was growing, and in 1852, the railroad arrived. Manchester quickly became a busy railroad center. Even though the railroad station was about a half mile from Manchester, the town continued to grow.

During the Civil War, Manchester was completely destroyed by the Union troops. After the war was over, Manchester was rebuilt and continued to flourish.

In 1872, Wedgefield, South Carolina, became the railroad's main shipping center. With the loss of the railroad business, Manchester quickly became a ghost town. Only a historical marker marks the site of this once busy town. The Manchester site is located in the Manchester State Forest in Sumter and Clarendon Counties. The forest consists of about twenty five thousand acres. In 1989, Hurricane Hugo severely damaged the forest. About 65 percent of the timber was destroyed.

THE GHOST OF ALICE

With Spanish moss draped over the old oak trees, hanging like ghostly fingers, the fog that slowly creeps in on a dark, moonless night only adds to the eeriness of the South Carolina coast. No wonder it's the perfect place for unsettled spirits to roam. Have these restless spirits been unable to get to their heavenly realm? Are they destined to haunt the coast of South Carolina forever?

The ghost of Alice Flagg has become legendary on the coast of South Carolina, rivaled only by the Gray Man of Pawleys Island. When Alice is not wandering around the graveyard or haunting her Heritage home in Murrells Inlet, she lays sleeping in her grave under a solid marble slab with just one word inscribed on it: ALICE. Or does she?

In 1849, Dr. Allard Flagg, a prominent doctor in the area, moved into his new home in Murrells Inlet, the Hermitage. Soon after he got settled in, he invited his widowed mother and sixteen-year-old sister, Alice, to join him at the Hermitage. Dr. Flagg took over as the family patriarch when their father died. Now, as head of the house, it was Dr. Flagg's responsibility to see that Alice was brought up to someday marry into South Carolina's aristocracy. But no one could control Alice's heart. Not interested in anyone from the plantations, Alice fell in love with a common lumberman. This was not going to sit right with her family.

One day, the lumberman came to call on Alice but was met by Dr. Flagg. After talking with the man, Flagg decided that this man was beneath his family. He was not going to allow a mere commoner to marry into the Flagg family. Such a thing simply could not happen, so Flagg sent the man away before he could speak with Alice. Alice, in love with this man, paid no attention to the dressing down from Dr. Flagg and her mother. The lumberman came calling on Alice again. As Alice was about to get into the buggy, Dr. Flagg came storming out of the house screaming at the top of his voice. He refused to let Alice ride with the lumberman; he gave the lumberman a horse and made him ride beside the buggy. Dr. Flagg rode in the buggy with Alice. No matter what she said, she could tell her mother and brother didn't care about her feelings. All they cared about was their social standings in the community.

Alice continued to see the lumberman in secret. On one of their meetings the lumberman proposed to Alice. Without a second thought, she accepted the engagement ring and placed it on her finger. When Dr. Flagg found out about the engagement, he was beside himself. He refused

to let Alice wear the ring on her finger. Alice, wanting to keep the ring near, wore it on a ribbon around her neck. One day, her mother discovered the ring and threw a tantrum. After much discussion, it was decided that Alice would be sent to Charleston to attend school. With no say in the matter, Alice was sent off.

Being alone and living in a strange city and the grief over losing her one true love took their toll on Alice. One night after attending a ball, Alice fell sick. A physician was summoned immediately to her side. After examining Alice, the physician determined that she had malaria. Word was sent to Dr. Flagg about Alice's illness. He left immediately for Charleston. When he finally arrived, he found Alice delirious. He asked for her trunk to be packed; he was taking Alice back home to the Hermitage in Murrells Inlet. The journey back to Murrells Inlet was filled with obstacles. It rained, the sky was dark, the roads were wet and they had to cross seven rivers by ferry. Finally arriving at the Hermitage, Dr. Flagg realized that Alice was much worse.

When Dr. Flagg was examining Alice, he discovered the ring she was wearing around her neck. Snatching it, he threw it into the marsh. Alice drifted into and out of consciousness all night. When she would become conscious, she would reach for her ring. When she could not find it, she would cry out in her weakened state, "I want my ring." She pleaded with them to give her back her ring, but the ring was never returned. By morning, Alice had expired.

Alice was dressed in her favorite white dress and laid to rest in the Flagg family plot in All Saints Cemetery near Pawleys Island. A plain marble slab was placed over her grave with her first name inscribed on it. Dr. Flagg refused to let anything else be inscribed on the marble slab, as he felt she had disgraced the Flagg family.

Another version of the story is that she died of a broken heart.

There have been many accounts of people seeing the ghost of Alice. In one account, Alice is seen moving around in the marsh as if she is looking for something. In another account, she is seen walking around the graveyard with one hand on her chest like she is looking for something. She has also been seen many times at the Hermitage, coming in the front door and moving silently up the stairs to her bedroom. Sometimes her visits are early in the morning or late at night.

THE GRAY MAN

The Gray Man is South Carolina's most famous ghost resident. You can't pick up a book on South Carolina ghosts that doesn't have at least one story on the Gray Man. His appearance means that danger is lurking soon. Those selected few who see him had better heed his warning.

The Gray Man of Pawleys Island is believed to have been first seen in 1822. This spirit has walked the beach at Pawleys Island ever since. It has long been a practice for the Gray Man to show himself as a warning of an impending disaster. He is most likely to appear in late September and October during hurricane season. He was seen again just before the tidal wave in 1893.

There are some disagreements about the true identity of this helpful spirit. No one really knows who the Gray Man is or where he came from. There are a number of different stories surrounding this mystery. Some say the Gray Man is the spirit of the island. Some say it's the ghost of the original owner of the island, Percival Pawley. The people in history, their names and dates have been confused with the passing of time because many stories have been handed down about the Gray Man. Each story has a slightly different meaning. All legends of the Gray Man contain romance and tragedy. Who he is and where he came from will never be known. But one thing's for sure: he's still here, making his appearances on the beach at Pawleys Island. No matter what the story is, the romance, the mystery and the Gray Man of Pawleys Island remain.

The legend of the Gray Man was once again revived in April 1954. According to witnesses, the Gray Man walks the beach at Pawleys Island before a hurricane hits. Everyone who has come in contact with him says he warns them to leave the island because danger is approaching. Those who heeded the warning of this helpful spirit and left the island have returned after the hurricane to find their homes undamaged. Homes on both sides, front and back have been destroyed, but theirs were left standing.

Some say they witnessed him walking the beach, and some say he was standing on the sand dunes looking out toward the sea. Others say he will knock on your door. Eyewitnesses say he's always dressed in old gray clothes of an earlier century. No one has been able to see his face. He warns them and then disappears in a swirling mist and howling wind. The Gray Man seems to be a permanent resident of Pawleys Island. What causes this spirit to return and warn certain people of approaching danger?

THE GRAY MAN OF 1822

Some say this happened in the summer of 1822. Other stories have different dates, but all indicate 1822 as the year. This story began shortly before a storm that brought much destruction to coastal South Carolina. During this period, there were many resort and vacation settlements along the South Carolina coast. One of the settlements was Pawleys Island, a subtropical paradise separated from the mainland by inlets and marshes. Many wealthy plantation owners had summer homes on Pawleys Island where they would vacation.

A beautiful young lady would spend her summers at North Inlet with her father and younger sisters. Her lover had been abroad for about two years but had continued to correspond with her through letters. The young girl was so much in love with him that she discouraged other suitors from calling. One day, a message arrived announcing that her lover was in Charleston to see his family. He was coming to his father's summer home in Pawleys Island. As soon as possible, he would ride down and ask her to marry him. Excited over the upcoming arrival of her lover, she prepared a grand reception in his honor. The home was decorated fit to receive a king.

The young man arrived at the family home in Pawleys Island early in the morning. After spending a short period of time with his family, he told them that as soon as possible he would be on his way to North Inlet to ask for the hand of his bride-to-be. He prepared for his departure to North Inlet. The heat was terrific at that time of day. His mother suggested that he wait until the cooler afternoon to leave. After having not seen his sweetheart for two years, he was not going to wait another minute. Two horses were made ready for the trip, and the young man and his servant were soon on their way to North Inlet.

Both men and horses were hot, tired and thirsty. The servant insisted that they stop at one of the houses at DeBordieu for some water and rest. Most of the houses belonged to family and friends, and that would mean delays that the young man didn't want. The young man, anxious to see his intended, decided to continue on. He told his servant that they could water the horses at the Middleton pond, a freshwater pond just north. When they could see the freshwater pond, he challenged his servant to a race. The young man took off through a marshy area. Before he knew what was happening, his horse jumped forward and the young man was thrown. Terrified, he realized that he and his horse were in quicksand and were sinking fast. There was nothing they could do to get out. Death was

only seconds away. The young man would never again see his sweetheart. As the seconds passed, they continued to sink deeper. He shouted for his servant, who was just arriving. The servant tried throwing the horse's bridle to the young man, but it was too short. The servant ran into the woods in search of a tree limb or something that he could reach the young man with. He found nothing. The servant, realizing that there was nothing he could do, yelled for help as he watched the young man and his horse disappear into the quicksand. Finally, people from DeBordieu heard his cries for help and came running. The servant told them what had happened. There was nothing they could do, so there was no need for them to remain there any longer.

The servant took the news of this tragic event to the young man's sweetheart and his parents. Devastated by the loss of her true love, the girl began walking the beach, remembering their happier days. Two days before the disastrous storm of 1822, the young girl was walking alone along the beach at North Inlet. She saw a figure of a man dressed in gray clothes in a swirling haze in the distance. The closer she came to him, the more he resembled her departed lover. At about ten feet from him, she was sure it was her sweetheart although she could not see his face well enough to recognize him. She felt no fear as she reached out to him. As she reached, he disappeared in the mist.

At supper, she told her father and younger sisters about the gray figure she had seen and how he disappeared as she reached out to him. The father decided that this gray man was the imagination of a broken-hearted girl or an omen of some kind.

After retiring for the night, sleep came slowly to the grief-stricken girl. She had a strange and frightening dream that woke her up. She could not get back to sleep for thinking about the dream. She ran to her father's room and told him about it. The next day, they moved back to their plantation home. Concerned about his oldest daughter's health and mental condition, the father planned to take her to a noted physician in Charleston. Before they reached their home, the skies became darker and the wind began to howl. The storm was getting increasingly worse as they reached their plantation home. Safely in their home, they watched as the weather took a nasty turn for the worse. The sky was now black and the winds increasingly stronger. The next day about dark, a hurricane hit the island with such a fury as had never before been seen. It continued to batter the island with heavy rain, strong wind and high surf. It continued for almost two days before the storm began to let up.

When the storm had passed, the news of the great destruction of the island came. Almost the entire population of North Inlet perished. In the days following the hurricane, the young girl truly believed that the Gray Man was her departed sweetheart. She believed he had returned to warn her of the impending tragedy. Until her death, she believed that her lost sweetheart had warned her the only way he could.

CAROLINA COUNTRY STORE

Kelly Fuller brought this story to my attention. None of my research over the years has turned up anything on Carolina Country Store, located on Highway 17 between Georgetown and Charleston in the North Santee community. When Kelly stopped by to get some information and photos for a story that she was doing for the *Georgetown Times*, the owner, Dave Bilderback, and cooks Tangie Self and Sarah Johnson began telling her about the ghost that haunts the store. They call her Mary Jane. While Kelly was there, she saw the doorknob moving and heard someone or something knocking on the back exit door. When Tangie opened the door, no one was there.

The store now known as Carolina Country Store was once called Delta Mercantile; the owner at that time was Cecil Thames. The store was built in 1929 and still holds much of its charm. A few repairs have been made over the years, but overall it's much the same. The shelves are original, but some old counters and display cases have been added. You can't tell that any repairs have been made to the store. When you're driving down Highway 17 and realize it's time for a snack, in this area that means a drink and a nab. For you dear readers who don't know what a nab is, it's a Lance Toast Chee Peanut Butter cracker. It's been a favorite in the South for as long as I can remember, and that goes back a while. It's a real southern epicurean's delight. When you pull off the road into the parking lot of the Carolina Country Store, you're stepping from the present back in time. Depending on the time of day, you might want to join the locals for a real country breakfast or lunch in the small restaurant in back. The food is great and so is the conversation. Who knows who or what you might see while you're there.

As I walked into the Carolina Country Store, it was like I had taken a journey into the past. Many antiques are placed throughout the store. I talked with Dave for a few minutes and then journeyed into the back of the

store, where most of the unusual things happen. The back is now used for a kitchen and two small dining areas.

Kelly and I took a table near the kitchen so we could talk with Tangie and Sarah. They were busy, so we couldn't talk much. We ordered lunch and were sitting at the table talking about Mary Jane when Kelly made the comment that the lights flickered. I looked up, and the chandelier started moving. It was swinging from side to side. This happened at 11:10 a.m. We finished lunch with no other unusual activity. We exchanged phone numbers and made plans to return when they were not so busy.

About a week later, I was preparing notes for the day I would be filming at the Carolina Country Store and decided to do a phone interview with the two cooks, Tangie and Sarah. Tangie is a full-time cook, and she recalls that up until January or February 2011, everything at the store was normal. Customers came in and out buying different things. Many would stop long enough to talk or have their meal in the dining room in back. Then one day, unusual things started happening. No one had an explanation for what was going on. Doors started opening and closing while people were standing there. Doors would rattle, and doorknobs would turn but the door wouldn't open. When someone would go check on the doors, no one was there. The heat on the crockpot with the hot dog chili would mysteriously turn up. Tangie said that she told Mary Jane to stop turning up the pots or she would burn the store down; the crockpots stopped being turned up. From time to time, the outside wooden door closes by itself. They also hear what sounds like the handles on fire extinguishers going up and down. Tangie reported hearing what sounded like someone calling her name, but no one was there. One afternoon while business was slow, Tangie was sitting in one of the rocking chairs on the porch, slightly rocking. The rocking chair beside her started rocking with no one in it. Tangie was the only person on the porch at the time. Tangie said someone had told them long ago that it was Mary Jane who was haunting the store. Mary Jane was a black lady who walked the road in front of the store many years ago. The story goes that she was hit and killed by a drunk driver.

Sarah was a part-time cook at Carolina Country Store. She reported hearing her name called several times when no one was there. She has seen doors open and close by themselves. Once she saw a shadow for just a few seconds. She said the ghostly visitations started in January or February 2011.

My next visit to the Carolina Country Store was to get the papers signed so I could film a short video on the store and its history. When I returned, Tangie had had another encounter with Mary Jane. Tangie was sitting at

the table when she felt a cold breeze on her legs. She looked around and noticed the door was open and staying open. That door won't stay open unless someone is holding it open. She tried to close it but met with some resistance. Nothing else happened after she got the door closed.

On April 2, 2011, James Ebert (my director), Kelly Fuller and I headed to the Carolina Country Store to film the video, not expecting anything to happen, thinking it was just another day at the office. However, this was not going to be our routine day of filming. We arrived, talked with Dave and Tangie for a bit and had lunch. We set up to film Dave in the front first. That went off without a hitch. James took his digital recorder and turned it on when we first sat down. It was left on the table recording the entire time.

We went into the dining area and set up to film Tangie. We checked the camera and mikes twice and started filming. After the first few minutes were filmed, I checked the sound. There was no sound. James checked the mike on Tangie, and it had been turned off. The mike was cut back on, and filming continued. Kelly told Tangie that she smelled something burning. Tangie rushed over to the crockpot since that was the only thing that was on. The crockpot had been turned up all the way. The hot dog chili was burnt beyond repair. Then there was a sound on the door like somebody had slapped it with their open hand. Tangie checked the door, and there was no one there.

We were all sitting at the table between takes, and James asked if anyone else was cold. Kelly, Tangie and I were quite comfortable; James was freezing. We finished filming without any other interesting happenings. That was enough excitement for the day. We packed up and headed home. James was playing his recorder as we traveled. At one spot, there seemed to be a third female voice on the recorder. You could not understand what she was saying. There were only two females in the store, Tangie Self and Kelly Fuller. Where did the third female voice come from?

HALLOWEEN

Fall has arrived, a little chill is in the air and the smell of wood and leaves burning fills the air. The autumn leaves change to the many hues of brilliant color. Nature's artist is at work. For many people, this is their favorite time of the year. Halloween is just around the corner. Homes and entire neighborhoods will be magically transformed into places of horror. It's time to let your imagination run wild. Halloween brings out the kid in all of us. Ghosts, goblins and ghouls will be lurking in every nook and cranny. The streets will be filled with these haunting little creatures. Jack-o'-lanterns and other ghostly decorations will grace every front porch.

Few people know the history of Halloween. We just enjoy it. It began in ages past, back when it was a harvest holiday when people celebrated a bountiful year. Some folklorists link its origin to the Roman feast of Pomona, the goddess of fruits and seed. Another version is the festival of the dead called Parentalia. Halloween is also linked to the Celtic festival of Samhain, originally spelled Samuin (pronounced *sow-an* or *sow-in*).

Halloween's roots are ancient; it began with traditions celebrated by pre-Christian Celts who once inhabited the British isles. The ancient Celts divided the year into two parts: Beltane, the growing season, and Samhain, which means summer's end.

It all started in the 800s, when the Catholic Church merged two Roman festivals called Feralia and Pomona's Day with Samhain. Feralia was a day for mourning and remembering the dead. By AD 1500, All Saints and All Saints Day had evolved into Hallow Time, October 31 through November 2. It wasn't long before All Hallow's Eve evolved into Halloween. Halloween is now celebrated on October 31. It wasn't until Christianity came to the islands that the devil became associated with Halloween.

Samhain was and still is considered to be a very mystical and magical time. It was considered to be a time when the spirits of the dearly departed could return and walk among the living. It was believed that the veil between this world and the hereafter is the thinnest at this time of the year. The druid priests of the Celts used this time to their best advantage. These were the days to contact the spirits of the ancestors on the other side. Halloween has evolved over hundreds of years to what we know now. The Halloween we celebrate today bears little resemblance to its origin.

The Jack-O'-Lantern

The tradition of carving the jack-o'-lantern has been around for hundreds of years. The tradition was brought to America by the Irish. There are several different legends to the history of the jack-o'-lantern.

According to Irish mythology, a man named Stingy Jack had tricked the devil. The result of this trick was that the devil could never claim Jack's soul. When Jack finally died, he found that he couldn't get into heaven either. The devil couldn't have him and heaven didn't want him. Jack was stuck in the middle of nowhere to wander in total darkness for eternity. The devil gave Jack an ember from the fiery pits of hell to help him light his way. Jack hollowed out a turnip and placed the fiery red ember inside. Ever since that day, Jack has roamed the earth, trapped between heaven and hell. That strange light you see in the distance just might be Jack still searching for a resting place.

Another version of the jack-o'-lantern legend is about a man named Jack who was having a drink with the devil. Somehow, Jack managed to trick the devil into turning himself into a coin. Jack thought that by putting the coin next to the cross he carried in his pocket, he would keep the devil bound. When Jack died on the next Hallow's Eve, he found that he could not enter heaven or hell. He was not wanted by either. He was alone and in total darkness. When Jack told the devil that he could not see to find his way, the devil gave him a red-hot coal from hell. Jack placed the coal in a hollowed-out turnip and used that as a lantern to light his way. Jack still wanders around looking for his final resting place.

Another legend comes from Ireland and Scotland, where turnips were carved into lanterns as a way of remembering souls held in purgatory. The Irish carve their jack-o'-lanterns on All Hallow's Eve and put candles in them to keep away evil spirits. The original jack-o'-lanterns were carved from turnips, potatoes, gourds, rutabagas and beets.

The American tradition of carving pumpkins was first recorded in 1837 and was associated with harvest time, not with Halloween. Carving pumpkins and jack-o'-lanterns were not associated with Halloween until the mid- to late nineteenth century.

Trick-or-Treating

The practice of dressing up and going door to door for treats dates back to the middle ages and the practice of souling. The adult poor folks in

the community would go door to door on November 1 receiving food in exchange for prayers for the dead. It is not said what type of clothes they dressed up in.

Another tradition of trick-or-treating goes back to the early celebrations of Samhain. It was believed that the spirits of the dead that crossed over on that night would be a little mischievous and play tricks on the living. To appease the spirits and avoid the tricks, people would leave treats and drinks outside their homes for the druid priests to offer the spirits.

Trick-or-treating today is different from the middle ages. It is a customary celebration for young children on Halloween. Children dress in every costume imaginable and go from house to house hollering, "Trick or treat!" The people in the house will give them candy or other treats to keep them from playing tricks on them.

Witches

There are many legends where witches and Halloween come together. One legend is that on All Hallow's Eve, a priest was making his way down an old country road when he saw a glow up ahead. As he continued to walk, he hastened his step. As he approached the area, he saw a fire burning up on a hill and people in dark costumes with torches and long sticks in their hands dancing around the fire. With the full moon in the background shining through the trees, it appeared that the people were flying in the air. The priest hurried on to the village and told the villagers about the witches flying on broomsticks. This is believed to be where the idea of witches dressed in black and flying on broomsticks on Halloween came from.

Witches were revered in ancient times, as they were women who helped the sick. They were often known as healers. When the rise of Christianity came about, witches were deemed evil because they couldn't explain where they received their healing powers. They were often condemned because their powers to heal supposedly came from somewhere other than God. Accusations of witchcraft were often used to keep talented, intelligent women from threatening male supremacy.

One of the most enduring symbols of modern-day Halloween is the witch. These women are portrayed as ugly, evil and sometimes with green skin and warts on their noses. These ugly female creatures are usually seen flying on broomsticks or stirring their black cauldrons.

Costumes

One of the best-loved holiday traditions in America today is donning a costume. For one day, it gives the old and young a chance to be someone else. Many years ago, adults began dressing in elaborate costumes for Halloween or masquerade parties. With the increasing popularity of costumes, children joined in. Before long, Halloween night was filled with ghosts, goblins and other horrifying creatures of the night.

THE LOWCOUNTRY

HOUSE NO. 90

A rental notice kept appearing in the local newspaper and out-of-town periodicals advertising a furnished, old-fashioned home with eleven bedrooms, formal reception room, dressing room, servants' quarters and much more. This house must be seen to be believed. This stately mansion would be an asset to any family wishing to move to Charleston, South Carolina. The notice read that there were very low rental rates. Sometimes the ad would run months at a time with no response. No one seemed interested in renting or buying this stately old mansion.

Neighbors knew that they would never find a renter or buyer for old no. 90, and if some unsuspecting customer did rent or buy it, they wouldn't last long—no one lasted long in this old mansion. The exact address or location of old no. 90 is not given, but it is or was located somewhere in Charleston.

A group of Charlestonians was gathered for a dinner party one night, and the conversations became brisk. As the waiter kept the champagne pouring, many subjects were discussed, from mushrooms to ghosts. One of the many guests, a Mr. Hollyoak—an anti-ghost person, definitely a nonbeliever in visits from the dead—had a bit too much bubbly and declared that he wanted to spend the night in the most haunted house in Charleston or anywhere around, for that matter. The more haunted it was, the better he would like it. He was going to prove that ghosts don't exist and are just figments of an

overactive imagination. No rational person would believe that a person can return after meeting his maker.

The host assured Mr. Hollyoak that he could fulfill his wish. He would arrange for him to spend the night in an old family mansion that was so haunted some of the adjoining mansions were vacant. Some of the neighbors had moved away due to the spirits in the old mansion. The host told Mr. Hollyoak that he would be spending the night in old no. 90, a house that no one could stay in.

After the death of the last owner, the mansion had passed on to his next of kin, who lived abroad. Not wanting to return to Charleston, he employed an agent to rent the mansion. Year by year went by; the rent was lowered to almost nothing. Still the old mansion stood empty. No one was interested in renting the old home at any price. Rumors of the most ghastly events were afloat. The evil events that happened in no. 90 were whispered about. Everyone was afraid to say just what happened in no. 90. Much of the happenings remain a secret. For many years, this desirable family mansion had remained empty. Its only residents were rats by day and something evil by night. Residents out walking would cross the street so as not to have to walk by the mansion. It cast a shadow of fear on everyone who walked by it.

Mr. Hollyoak grabbed the opportunity on the spot to prove there were no such things as ghost or evil spirits. Another guest was assigned the duty to be witness that Mr. Hollyoak did indeed spend the night in the frightful old mansion—a night Mr. Hollyoak would remember the rest of his life, no matter how short it was.

At ten o'clock sharp, they met with the caretaker on the steps of the foreboding mansion. The caretaker unlocked the door, and Mr. Hollyoak stepped into the long, dark hallway. He looked back at the witness and the caretaker and slammed the door behind himself. Mr. Hollyoak told them to go home and call for him at precisely eight o'clock in the morning, not one minute later. The caretaker excused himself and made a hasty retreat, not wanting to stay there a minute longer than necessary. The witness returned to his assigned location.

The following morning, the caretaker and the witness called for Mr. Hollyoak at precisely eight o'clock. The caretaker unlocked the door and the witness called for Mr. Hollyoak. Mr. Hollyoak exited the door in seemingly good spirits. The witness asked what, if anything, had happened. Mr. Hollyoak told them that he would tell them the whole story as soon as he had breakfast. After Mr. Hollyoak and the witness finished breakfast, Mr. Hollyoak said:

The Lowcountry

I have seen them. When I went upstairs in search of suitable sleeping accommodations lighting my way with a match, I found a suitable room. As I was going upstairs, I noticed a room door slightly ajar with a bit of light shining through the partially open door. As I entered the room, I noticed the most cheerful fire in the fireplace. Thinking the caretaker had prepared this room for me, I settled down. There were a number of doors in the room, and my curiosity took the better of me. I went in search to see what mysteries were hidden behind the doors. Much to my disappointment, they proved to be cupboards or closets—no mystery here. I investigated the rest of the room and found nothing. I sat down by the fire, bathing in the glow and listening to the crackling embers, and opened my favorite book and began to read. Chapter after chapter I read, thinking this was going to be a most uneventful night. Not one sound, no ghostly figures. Then I was startled by the old church bell as it tolled the midnight hour.

Then I heard a faint sound coming down the hall, a rat or some other small furry woodland creature that had taken refuge in the old house, no doubt. I was wondering if those pesky rodents were going to keep me awake all night. The sound, coming nearer and nearer, got louder and louder. This could not be rats, I thought. As the sound neared the door, it sounded like many feet passing by. Then silence; the only sound was the crackling of the fire.

As I opened my book again, I heard a knock on the door. I sat there a little startled, waiting to see if anything else would happen. Then another knock, this one with authority. I slowly approached the door with the fire poker in hand. I swung the door open, and there stood a tall footman making a formal invitation. "Dinner is served." I declined his invitation, slammed the door and retired back to my book. Moments later, there was another knock on the door. As I slowly opened the door, there stood a tall butler in the hall. "Dinner is served and the guest awaits your presence." "I'm not going," and slammed the door again. The door slowly opened, and there stood the butler. "The master says you must come and dine with us." "All right, I'm coming," and I followed the butler down the stairs. I could see several servants moving about in the house. The sound coming from the formal dining room was reminiscent of an 1800s party. As I was ushered into the room, a voice announced me as Mr. Hollyoak. "How do they, whoever they are, know my name?"

About two dozen people dressed in eighteenth-century clothes were seated at a large table set for a Christmas feast and lighted by two large candelabras, one at each end of the table. An elderly gentleman rose from

the end of the table and gave a bow. He motioned with one hand for me to have a seat in the empty chair between two elegantly dressed beauties. These were two of the loveliest ladies I've ever seen.

I looked around the table for a familiar face, but none could I find. There were the young, the old, the handsome, the beautiful and, of course, the reverse. As I looked closer, I noticed all the faces were expressionless. These people looked as though they belonged to the upper crust of Charleston society from a bygone era.

The host rose and tapped his glass with a piece of well-polished silver. "Permit me to make the first toast to our honored guest." Each guest raised their wine glass to the toast. "I am honored, and I beg of you let me say grace." As I recited a Latin benediction, I heard violent crashes, an uproar

of horrible screams and then total silence and total darkness. I found myself standing alone in a huge dining room with the biggest dining table that was once surrounded by people—or what appeared to be people—having a gay old time. The table was now bare of all the Christmas dinner and candelabras. I stood there a few moments, getting my thoughts in hand. Then I made an impolite hasty retreat to my suite. I was going to get a good night's sleep, eighteenth-century ghosts or not.

It seemed like I had just dozed off as I was awakened by the cheerful noise of the world outside. I had spent the night and survived. I arose from my bed and washed my face with water that was left by the caretaker—or at least I hope he left it. I dressed at my leisure, strolled downstairs to find waiting on the outside the witness and the caretaker. I will sleep there again tonight. I must find out who those people were and where they came from. They meant me no harm, but I must know.

That night, Mr. Hollyoak and his faithful dog entered the foreboding mansion. He took the key from the caretaker so no one from outside could enter. At dawn, as instructed, his friend and the caretaker showed up. They waited outside, but Mr. Hollyoak did not exit as planned. The friend knocked, but there was no answer. The caretaker joined in; still no answer. The friend took it upon himself to look through the keyhole. To his surprise, a fiery eye was looking back at him. He removed his eye and shouted through the keyhole. Unable to get in or wake Mr. Hollyoak, he began pounding on the door. That attracted the attention of a passing policeman. The caretaker, explaining that he had given the key to Mr. Hollyoak, procured a locksmith who lived nearby. After minutes of delay, the huge door swung open. Mr. Hollyoak was lying dead at the bottom of the stairs. There were no marks on his body. The official cause of death was by fright. Did Mr. Hollyoak die of fright or from some other sinister means?

HAINTS, HAGS AND PLAT EYES

The South Carolina Lowcountry is riddled with stories of ghosts, goblins and all sorts of haints, as some people refer to them. Many of these stories come from the Gullah culture. The Lowcountry has always been the perfect place for these creepy creatures that inhabit the night—or at least our overactive imaginations.

Many people call them haints, plat eyes or hags. These unexplained creatures were the perfect explanation for unexplainable events. They were the scapegoats for strange behavior of friends and neighbors. Haints are the souls of people who expired before their time and their souls cannot rest. For whatever reason, the soul cannot move on or is trapped between here and the hereafter. Haints are not harmful to living beings and sometimes can be beneficial.

Hags are similar to witches because they are women. Hags don't cook up spells in big black cauldrons or fly around on broomsticks like Halloween witches do. In the daylight, hags are just ordinary women. They could be ugly or beautiful young women. A hag could be your mother-in-law. It's only after dark that these creatures come out to play. A hag sheds her skin and floats through the air seeking her next victim. A hag attacks her victim while it is asleep. She can enter your home through any opening: an open window or door, a keyhole, a crack in the wall or an opening around a pipe. Once inside the house, she seeks out her next sleeping victim. The hag will ride the sleeping victim throughout the night. Even though you slept through the night, you will wake up feeling tired.

There are several ways to stop a hag from entering your house. The most popular is to paint the window and doorframes blue. Another popular way is to place seed at the bottom of the doors and windows. A hag will stop, pick up and count every seed. Another way to keep the hag out of your bedroom is to stand a broom upside down outside your door. A hag will count every straw in the broom. Another good method, and probably the best for warding off the old hag, is to hang a horseshoe over the door. The hag will travel every mile that the horseshoe has traveled.

Plat eyes are spirits that can take the form of animals or objects. When not disguised as an animal or object, they have one big round eye. They haunt low-lying areas such as swamps. If you stay away from swamps, you should be safe.

THE GHOST CAR

In 1946, a green 1940 Oldsmobile with five passengers was driving over the Cooper River Bridge at the same time a boat was going under the bridge. The captain of the boat lost control and hit one of the bridge supports and caused the car to tumble into the water below. No one was there to rescue

the five people in the car. Almost a month passed before rescuers could find the car due to the currents. When the car was recovered, the five bodies were still in the car. There have been reports of people seeing a green 1940 Oldsmobile crossing the Cooper River Bridge.

SIMMONS ALLEY

Simmons Alley is located at 131 Tradd Street in Charleston. The ghost of a woman haunts the alley where her house once stood.

Francis Simmons married Ruth Lowndes in a ceremony that should never have been. Francis was in love with another woman but had already proposed to Ruth. In the 1800s, a man was only as good as his word, and Francis, being a man of his word, married Ruth. They moved into a house at 131 Tradd Street on the night of their marriage. They rarely spoke to each other, and as things got worse, Francis moved out. Ruth, having to spend her nights alone in their house, became more and more bitter. She died a lonely, bitter woman.

After her death, people reported hearing a carriage pull up in front of the house. The house has long been gone, but the spirit of Ruth Simmons still haunts the alley where the house once stood.

THE *MALCOLM*

I was unable to locate the date of the discovery of the *Malcolm* boat or who discovered it. The *Malcolm* was excavated from the Ashley River just outside Charleston in 1992. The *Malcolm* is believed to have had a long career. After many years of river travel, it finally reached the end of its usefulness. The owners stripped the *Malcolm* of all useful material and supplies and abandoned it on the bank of the Ashley River. The few artifacts left on the *Malcolm* when it was abandoned could be dated to the last quarter of the eighteenth century and the early part of the nineteenth century.

It is unknown where the *Malcolm* was built, but the use of local timber suggests that it may have been built in South Carolina or Georgia. It is possible that the lumber was shipped to another state and the boat was built there and sent to South Carolina. Some believe that the *Malcolm* could have

been in use during the antebellum period. The boat was forty-one feet, ten inches long; the beam was eleven feet, nine inches long; and the depth of the hold was four feet, eleven inches.

The Headless Horseman of Fenwick Hall

Fenwick Hall, also known as Fenwick Castle, has been home to some of the most prominent families in Charleston. It was built on John's Island by Edward Fenwick. Fenwick, known in England as Lord Ripon, built his mansion to resemble his family castle in England. It is legendary for family betrayals, hidden tunnels and secret rooms and is shrouded by other mysteries.

The British occupied Fenwick Hall and the Union soldiers didn't torch it, so it has stood the test of time. Since the Civil War, Fenwick Hall has survived many owners and years of neglect. Cornwallis made his headquarters in the old house even though it was falling into disarray.

Edward Fenwick was well known in the area for his love of fine English Thoroughbred horses. Ann Fenwick, Edward Fenwick's seventeen-year-old daughter, had a great love for the Thoroughbreds and for their caregiver, Tony. Ann, deeply in love with Tony, asked her father several times for permission to wed Tony. Lord Ripon refused each time to let his daughter marry. After her father's last refusal, Ann and Tony decided to elope. They chose to elope at night in hopes of being long gone before they were discovered missing. They traveled through the marshes of the Ashley River only to find there were no available boats. They hid in an old abandoned cabin in hopes of being safe until they could make their getaway. In the early dawn hours, Lord Ripon and a group of his men discovered them. Ann told her father that she and Tony had already been married for several days; they had Reverend Marshal perform the nuptials in private. Lord Ripon, beside himself with anger over his daughter's wedding, had his men place Tony on the back of a horse, and one of them placed a rope around his neck. Lord Ripon placed a whip in Ann's hands and ordered her to strike the horse. Ann, seeing her husband hanging from the old oak tree, screamed and then collapsed. She was taken back to the house and was never convinced of the terrible ordeal that had just taken place. The years passed by with Ann still calling out his name. Tony never answered. She continued to search for her long-lost

husband until her death. Ann's footsteps can still be heard as she walks up and down the halls of Fenwick Hall, mournfully crying out for her husband. Others have reported seeing the ghost of Tony riding through the marsh when the moon is full. Some say they have seen a horse with a headless rider riding through the marsh.

Today, Fenwick Hall is one of the most historic eighteenth-century plantations in America. For many years Fenwick Hall remained in ruins, haunted and feared by all. In the 1950s and early 1960s, it was completely restored to its original beauty.

Strawberry Ferry Landing

Associated with Childsbury, Strawberry Ferry Landing was established in 1705 on the western branch of the Cooper River. Like all frontier towns located on a waterway, a landing was essential to the survival of the town. Goods were shipped to and from the towns and had to have a landing so the ships or ferries could dock.

With the demise of Childsbury, the landing fell into a state of disrepair. The ferry landing brick rubble extends out about twenty yards from the bank. The brick rubble ends about fifty feet from the shipwreck described in the next section.

Strawberry Shipwreck

During an expedition in the summer of 1781 to chase the British out of Moncks Corner, Colonel Wade Hampton and his men arrived at Strawberry Landing on their way upriver. To Hampton's surprise, they found four ships loaded with military and other supplies for the British. Hampton ordered his men to burn the ships. The Strawberry shipwreck displays evidence of burning. Artifacts recovered in the 1970s from the Strawberry shipwreck were of British military origin.

The Pimlico Shipwreck

The discovery of the Pimlico shipwreck was first reported by a hobby diver from Abbeville in 1993. The ship was discovered in twenty-five to thirty feet of water in the west branch of the Cooper River. The remains lie off a small island near the west bank. In October 1999, the underwater archaeology division from the South Carolina Institute of Archaeology and Anthropology (SCIAA) worked on the Pimlico shipwreck. The strong tidal currents in the river bend made working on the wreck site a real challenge.

The large dimensions of the ship suggest that the owner might have used the ship for offshore rather than inland waterways. When the starboard side was exposed and measured, it measured sixty-two feet, four inches. Several

features of the ship may suggest that it had been rigged as a schooner. Schooners were one of the most popular boats in South Carolina.

Shards of Native American Indian pottery were discovered at the Pimlico shipwreck site. The reason for the pottery being there has not been determined. The pottery has not been dated.

I have not been able to find the date the ship was built, when it sank, what sank it or for what the ship was used.

The Mepkin Abbey Shipwreck

In 1970, R.D. Densler Jr. (known locally as Captain Bob) was a senior diver for the North Charleston volunteer rescue squad. As the water was getting warmer, Captain Bob took a fellow rescue squad member and friend Don on a dive in the Cooper River near Mepkin Abbey. During the dive, Captain Bob spotted an anchor line lying on the river bottom. Bob followed the anchor line into the ribs of an old wooden shipwreck. He got water in his face mask, and they returned to the surface.

The following Saturday, Captain Bob and a crew—Julian "Muck" Muckenfuss and Captain Bob's father, R.D. Densler Sr.—returned to the location. As Captain Bob and Muck descended toward the bottom, the visibility was good and the currents were not running too fast. They reached the shipwreck with no problems. Captain Bob spotted a stoneware jug near the shipwreck and returned topside with the jug. He then returned to the wreck in search of more artifacts. Captain Bob and Muck were canvassing an approximately fifty-foot-long sailing ship. From the first search, the ship seemed to be loaded with assorted lumber. Muck located another jug and a black glass bottle. At the end of the dive, they had recovered two bottles, a hammer and eleven stoneware jugs. Seeing the importance of this wreck, they reported it to Dr. Robert L. Stephenson, director of the SCIAA.

In 1978, Alan Albright, Ralph Wilbanks and Darby Erd from the SCIAA and Captain Bob returned to the shipwreck to scientifically map the wreck. The Mepkin Abbey ship measured forty-eight feet, three inches long and sixteen feet, ten inches wide. Archaeologists and researchers theorized that the shipwreck was the sloop *Baker* owned in the late 1700s by Mepkin Plantation owner Henry Laurens. No record is found of the date the ship sank or for what reason. Laurens was a dedicated American Patriot and one of the signers of the Declaration of Independence. He was born in

Charleston in 1724 and died at Mepkin Plantation in 1792. He was captured at sea while sailing to fulfill a mission during the American Revolutionary War. Laurens was the only American prisoner to be held in the Tower of London. After fifteen months, he was traded for Lord Cornwallis, who was captured at Yorktown in 1781. In 1783, Henry Laurens—along with John Jay, John Adams and Benjamin Franklin—represented the United States and signed the peace treaty in Paris, France, which brought an end to the Revolutionary War.

BLACKBEARD'S GHOST

Charleston is known as one of the most haunted cities in America. It is haunted by Civil War soldiers both Union and Confederate, plantation owners, slaves, young girls who died with broken hearts and many other apparitions. It seems that around every corner there's a ghost. With all the men who have faced horrifying deaths in the Charleston area over the centuries, it's no wonder that Charleston is a hot spot for ghostly activity. Will these ghostly figures ever make it to their heavenly realm?

One of the more famous ghosts to haunt the Charleston area is Edward Teach, better known as Blackbeard, the Terror of the Sea. Over the centuries, the ghosts of many pirates have been seen under the large oak trees along the area known as the Battery. Is it possible that these are the very trees used to hang the pirates? Could they still be haunting the place of their untimely demise? The ghost of Blackbeard has often been seen at Folly Island, which is only a few miles from Charleston and was one of Blackbeard's hideouts. Is he still haunting his old hideout?

Blackbeard was a tall man with long, black hair and a long beard that reached to his waist. A rumor that has followed Blackbeard is that he would sometimes set his rum on fire using gunpowder and then would drink it, fire and all. Some of his crew members thought he was the devil himself.

Edward Teach was born in Bristol, England, in 1680. He died on November 22, 1718. His active years as a pirate were from 1716 to 1718. For twenty-seven months, Blackbeard terrorized the sea, building a reputation as the most feared pirate of all. The Atlantic and Caribbean were his playground. He would ambush ships for their cargo and sometimes take the ships. He would attack in the dim light of the evening or early morning. Blackbeard was a shrewd and calculating leader. There are no accounts of Blackbeard

ever harming or killing any of his captives; all were released unharmed. He avoided the use of force when possible and preferred to use the fear tactic.

Blackbeard once blockaded Charleston with his ships. He took over a large cargo ship caring many wealthy people that was sailing out of Charleston. He took them hostage and held them for ransom. It was not money he was after; his demands were for a chest of medical supplies. The townspeople paid the ransom, and the hostages were released unharmed.

Blackbeard had attracted the attention of Governor Alexander Spotswood of Virginia. Since no one else had succeeded in capturing or killing Blackbeard, Governor Spotswood took it upon himself to take out

Blackbeard dead or alive. He wanted to capture the elusive pirate and take him to court. That was not going to be an easy job.

In the fall of 1718, Blackbeard returned to his favorite hideout at Ocracoke Island, North Carolina. The pirates hosted a big party with other famous pirates attending. Governor Spotswood of Virginia heard of the pirate gathering and decided to take action. He sent two small fast ships commanded by Lieutenant Robert Maynard of the Royal Navy to Ocracoke Island. Blackbeard's ships were the only ones left at Ocracoke Island when the Royal Navy reached it. Blackbeard refused to surrender. The Royal Navy and Blackbeard attacked each other. It was a fierce battle, with neither side giving in. Several of Blackbeard's ships were destroyed, and one of Maynard's ships was destroyed in the battle. Maynard's crew threw supplies over the side to lighten the load. He sent many of his crew below deck to make it look like he had lost a lot of crew. When the pirates boarded the navy ship, the crew emerged from below deck. The battle between the pirates and sailors began.

During the battle, Blackbeard and Maynard came face to face and stared each other down. With pistols drawn, both fired their pistols. Blackbeard missed his target, but Maynard's bullet hit the pirate. It was not a fatal shot, and Blackbeard continued to fight. He broke Maynard's sword in a battle of the swords. Finally, a sailor came up behind Blackbeard and cut his throat, ending the battle. After the battle was over, Blackbeard's head was cut off and hung on the bow of Maynard's sloop as a warning to other pirates. With the blood dripping from the severed head, you could almost see Blackbeard's eyes watching Maynard.

Blackbeard's headless body was buried near the lighthouse on Ocracoke Island by the residents. Over two hundred years later, Blackbeard's ghost still haunts the Charleston area.

OLD CITY JAIL

Charleston is also known as the Holy City. Or should it be called the haunted city? All of Charleston's historic buildings and locations have at least one resident ghost, maybe more. Most old cities in South Carolina have a darker past, and Charleston is no exception.

The Old City Jail stands in the heart of historic Charleston as a haunting reminder of its darker past. The jail was built in 1802 on the site of the

former hospital, poor man's house and slave workhouse. This is enough to have a ghost or two wandering around. The jail was in operation from 1802 until 1939. During its time of operation, it held some of Charleston's most infamous criminals, nineteenth-century pirates and many Civil War prisoners, both Yankees and Confederates. Thousands of human tragedies happened inside these walls. Many prisoners were brutally punished with shackles, whippings and many other types of torture. As the operation expanded, torture and executions at the old jail increased. Many swore they were innocent until their deaths. How many innocent people were executed at the old jail? All of this ended when the jail closed in 1939. Over ten thousand people died in the Old City Jail. No wonder these tortured souls are still haunting the location.

In 1822, a fireproof wing was added. In 1855, alterations were made at the jail and the fireproof wing was removed. In 1886, an earthquake did a lot of damage to the building. The tower and top floor were removed due to the amount of damage they sustained.

The Old City Jail is considered one of the most haunted buildings in South Carolina. Among the more famous prisoners to be held there were serial killers John and Lavinia Fisher (1819–20). They were convicted on several counts of murder of travelers at the Six Mile House. They were eventually hanged for their crimes. The ghosts of John and Lavinia Fisher are said to still haunt the jail. People have reported seeing their ghosts walking the halls where their cells were located.

Many other stories have been told throughout the years. One story is about an old Negro man dressed kind of ragged who seems to wander aimlessly throughout the building. People have reported a feeling of being watched, while others report being grabbed, pushed or touched. Some have reported smelling strange odors in the building. Some people reported that the strange odor would make them sick. There are cellphone disruptions, including calls from an unknown number and batteries going dead and then recharging. These types of incidents with cellphones have been reported at other haunted sites also.

During the 2000 renovation of the building, the building was kept locked at all times for months. When workers went in, they found bare footprints in the dust. Workers also saw the apparition of a jailer with a rifle pass through cell bars. One time during a tour, a heavy iron door fell off its hinges. Many other haunted incidents have been reported in the past and continue to be reported.

THE GHOST OF SUE HOWARD HARDY

Charleston has had a turbulent history from the beginning. Lives have been lost in battles that engulfed Charleston. Many lives were lost at sea or from broken hearts. Restless souls still wander the streets of Charleston. The old churches, buildings and graveyards are home to many of these restless spirits.

St. Philip's Episcopal Church cemetery is home to one of the souls that has not come to peace enough to cross over. Sue Howard Hardy is said to be one who haunts the graveyard. Sue was born in 1858 in Charleston. She later married Gaston Hardy. The two lived in Charleston and attended worship services at St. Philip's. When Sue announced that she was in a family way, Gaston was overcome with joy. The excitement was to be short-lived. On June 10, 1888, Sue's baby was stillborn. Sadness came over the Hardy family, but it wouldn't end there. On June 16, just six days later, Sue would take her last breath. No one knew why Sue died. Maybe she couldn't live with the death of her baby. Maybe sadness took her life.

The story of Sue Hardy didn't end with her death. Almost a century later, the ghost of a female was seen kneeling over Sue Hardy's grave. Since then, other strange things have been reported happening in the graveyard. Some pregnant ladies have reported feeling a sense of foreboding. Some have reported that they were having trouble breathing, as if someone or something, a strange unknown force, was squeezing the air out of their bodies. Some have reported an uneasy feeling came over them as they approached Sue Hardy's grave site. Is Sue Hardy still visiting the graveyard where she and her baby were laid to rest?

SONIC BOOM OVER THE LOWCOUNTRY

At 1:30 p.m. on a Friday afternoon in 2011, reports say that a sonic boom rattled the Lowcountry. An extremely loud noise was heard in Charleston, James Island, Daniel Island, Wadmalaw and West Ashley. There were no reports of fires or explosions in any of these areas. Calls were coming in to the police department, fire department and the earthquake center. The air force, air national guard, marines and National Weather Service also received calls. The air force, the South Carolina Air National Guard and the marines have planes stationed in the area that are capable of breaking the sound barrier. They need a seven-hundred-mile-an-hour clip to do

so, but all reported that they had no planes in the air flying at that speed. The navy reported that it didn't have any aircraft carriers off the coast of South Carolina. Charleston Southern University and the University of South Carolina earthquake experts ruled out any earthquakes in the area. There was only one theory left: Seneca guns, an explanation used to explain unexplained sonic booms on the coast of South Carolina.

There are several theories about what causes sonic booms, though none is proven. Two theories are gas being released from the ocean floor or a sudden rush of cold air hitting the Gulf Stream. Several theories that are a little more on the paranormal side are UFOs coming up out of the ocean; a crack in our dimension, allowing something from another dimension to enter; or a shift in time.

CAPE ROMAIN LIGHTHOUSES

These two lonely sentinels still stand watch over Cape Romain. Only three locations in America still have two lighthouses: Point Loma in San Diego, California; Cape Henry, Virginia; and Cape Romain, South Carolina.

In 1823, money was made available for the construction of the first lighthouse on Cape Romain. The first plan was to convert an existing stone windmill into the lighthouse. This plan, however, was not going to work. The area around the old windmill was easily flooded, so the plans were changed. After long negotiations, a piece of land on higher ground was secured.

In 1827, under the direction of Winslow Lewis, a brick conical tower was erected, standing sixty-five feet high. Lewis outfitted the lighthouse tower with a lamp and reflector system of his own design. Cape Romain Light was constructed six miles off the coast of McClellanville on Raccoon Key, now known as Lighthouse Island. The main purpose of the lighthouse was to alert mariners about a treacherous shoal nine miles southeast of the beacon. Due to the lighthouse's weak signal, it failed. The lighthouse was updated in 1847 but still didn't work.

A new lighthouse was constructed near the original lighthouse. This was a 150-foot-tall tower with a first-order Fresnel lens. The new and more powerful beacon was put into service on January 1, 1858. Shortly after the Civil War began, Confederates extinguished the light. They removed the lens and damaged the tower to prevent the Yankees from using it. After the Civil War ended, the tower was repaired, and the lighthouse was returned to service in

1866. The tower still had one problem: it had developed a conspicuous lean as the foundation settled. The leaning lighthouse was so bad that the lens had to be readjusted to properly work.

In 1937, the lighthouse was automated. Ten years later, the use of the lighthouse was discontinued. Today, only the foundations of the keeper's house and the boathouse remain. Only the bottom portion of the older lighthouse remains, but the newer lighthouse is still in remarkably good condition.

In the late nineteenth century, a Norwegian named Fischer was the lighthouse keeper. Fischer and his wife lived alone on the island. One night while they were eating supper, she spoke of wanting to go back home to Norway to see her family and friends. Fischer would not see this. He told his wife that her place was there with him. She told her husband that she missed her family and homeland and intended to go back. The argument became more heated. A storm was beginning to rage outside. The lightning began flashing as if it were hitting the ground. The sky would light up with each new flash, and thunder rumbled with a deafening sound. His wife grabbed her jewelry box and dashed out the door. Braving the storm, she headed into the night. The only light she had as she ran away from the house was the streaks of lightning. She fell down on her knees and began to dig a hole. As soon as the hole was deep enough, she buried the jewelry box. Then she headed back to the house. Fischer was standing in the door waiting on her to return. He stepped aside and let her in. Beside himself with anger, he grabbed a knife and stabbed her in the chest, killing her graveyard dead. On that stormy night, he buried her lifeless body near the lighthouse. He told everyone that she got depressed and committed suicide. No one would have ever known if he hadn't confessed to the grisly murder on his deathbed.

The future keepers of the lighthouse tended her grave. The lighthouse keepers and their family have reported hearing footsteps on the stairs, but no one has ever found anyone there. The floorboards of the keeper's house where the blood dropped have been repeatedly cleaned of her blood, but drops of blood still reappeared. The jewelry box has never been found.

The Ghost of Gauche

Beaufort has a long history and many unusual ghost stories. The story of Gauche, the dwarf jester, is one of the more mysterious ones. In 1562, Jean

Ribaut and a group of French Huguenots traveled from France in search of a new life. Settling on what is now Parris Island, the weary travelers established the colony of Charlesfort, not realizing this would be short-lived. Among the new arrivals was a dwarf named Gauche, a jester by trade, dressed in his colorful clothes, a blouse, hose stockings, pointed shoes, a cap and bells. The wrinkled old elf would entertain when the work for the day was done.

The conditions for the new arrivals were harsh, and many lost their lives, including Gauche. Disease and harsh weather conditions were taking their toll on the new settlers. There are several accounts of the death of Gauche, though none can be confirmed. Perhaps he fell victim to disease, or maybe Captain Albert had him hanged. In another version of his death, Gauche may have kept his shipmates-turned-cannibals alive on their tragic voyage back to France from their failed colony.

Another story puts the dwarf in another century. Grenauche le Griffien was born in Portugal, not France. He died in 1709 during a Yemassee Indian raid.

Wherever Gauche or Grenauche came from, it's believed that he's still here. No documents can be found that confirm that Gauche ever sailed with Jean Ribaut. Some people believe that it's under much more mysterious circumstances that Gauche made his appearance hundreds of years after Jean Ribaut's Charlesfort colony failed. Another version of his death is that he was killed in a brawl, not in Charlesfort, but close to the area where the castle is now located, miles away.

Reports of the ghost of the jester still haunt the castle and surrounding area. The castle, a Greek Revival home, was built on the intracoastal waterway in Beaufort in the 1850s by Dr. Joseph Johnson and is surrounded by live oaks and traditional gardens. Construction on the castle was halted by the outbreak of the Civil War, causing it to be unfinished for a long time. In 1861, when the Federal troops occupied Beaufort, the unfinished castle was used as a military hospital; the other building on the property was used as a morgue.

Dr. Joseph Johnson managed to reacquire the home after the Civil War ended and completed its construction. The home stayed in the Johnson family until 1981. Soon after the castle was completed, the gardeners began to report seeing many strange apparitions around the gardens. Dr. Johnson also reported seeing the ghost dwarf walk outside the house.

Lily Danner reported seeing the ghost of Gauche many times when she was a child. When Lily would have a tea party for her dolls in the basement of the castle, she would sometimes be joined by Gauche still dressed in his

colorful jester clothes. Mrs. Danner's brother once called Gauche a rough customer who always swears.

House guests have reported doors opening and closing and furniture moving, accompanied by the sound of a jester's bells. Some guests have reported seeing wisps of fog rise up out of the tidal creek near the house just after a chilling breeze blew by. The fog would slowly creep toward the castle and then take human form and vanish into the night. There have been several reports of red handprints left on some of the windows in the house.

The Strange Tale of Dr. Buzzard's Coffin

The old Beaufort Jailhouse is damp, dark, breezy and not the cleanest place in town. After all, only the black eye of society takes up temporary residence in this undesirable domicile. A jailer and three policemen handle the jail and the city. It's up to these to keep Beaufort free of crime. One day, they had a very strange request from the nationally known Beaufort witch doctor Dr. Buzzard: Dr. Buzzard had requested that they lock him in a coffin. He wanted to be locked in the coffin so he could give irrefutable and undisputed evidence that he had the power of voodoo and witchcraft that he claimed to possess. He wanted to prove a point.

The first Dr. Buzzard came to Beaufort on a slave ship. Shortly after he was given a cabin to live in, his master learned about his mystical powers. His master learned that he had a lot of influence over the other slaves and granted him a lot of freedom to use in his practice of witchcraft and voodoo. The people born into slavery and their descendants relied on those who practiced root for all their medical needs and many other needs. In the practice of root, various types of roots were mixed with cemetery dirt, crushed bones, frog's feet, eye of newt, stump water aged just right and hair clipped from a black cat under a full moon, among many other ingredients, and were used as charms.

As slaves would slip onto the property that Dr. Buzzard occupied to seek medical help for many maladies, Dr. Buzzard's son would watch and learn many of his father's black magic and voodoo secrets. As Dr. Buzzard reached the autumn of his life, his son would take over.

Another example of Dr. Buzzard's miracle magic was to use a black cat. Dr. Buzzard said there was no more powerful force on earth or anywhere else than comes from the bone of a black cat that has been boiled alive. Dr.

Buzzard would put a black cat into a pot of boiling water. When the jerking cat was completely covered by the boiling water, the cat would talk like a man. After the cat had been boiled, it was removed and put into a special sack and then taken to a river. The boiled cat was dropped into the river. All the meat would fall off the bones, and the bones would either float away or sink—except one. That bone would float back to where Dr. Buzzard was standing on the riverbank. That bone had the power, and anyone carrying that bone was safe from anything.

As the appointed day arrived, the three policemen and the jailer met Dr. Buzzard at the jail at the time he had requested. The policemen, as well as the citizens of Beaufort, respected and feared Dr. Buzzard and his powers of voodoo and witchcraft. He requested the officers and jailer use every chain and lock available to them in their effort to keep him from escaping from the coffin. His reasoning was that his escape from the chained coffin would be a testimony of the powers of black magic and witchcraft that had been handed down to him by his father. A coffin was ordered from the local funeral parlor by Dr. Buzzard and brought into the jail. Dr. Buzzard climbed into the coffin and made himself at home. When asked if he was ready for the policemen to close the lid and lock him in, Dr. Buzzard asked for the time. The jailer, looking at his watch, said, "Eleven o'clock." Dr. Buzzard replied, "Excellent, I'll dine with mother at the usual time, one o'clock."

The officers made one last request of Dr. Buzzard: "Are you sure you want to do this? We don't want to kill you." "You have brought me before your court many times; not once were you able to hold me. That should be a testimonial to my powers. This won't hold me either. Now close the lid," growled Dr. Buzzard. The jailer hurried and closed the coffin. The policemen wrapped the chains securely around the coffin and pulled them together as tight as possible. The chains were pulled together at the center of the coffin and locked. One of the policemen put the keys in his pocket. "Let's see Dr. Buzzard get out of this coffin now. There's no way he can get out of this," said a policeman.

The policemen and jailer left the jail unattended and went to a nearby restaurant for dinner. As the officers dined, they spoke about Dr. Buzzard and how he had acquired his mysterious powers or, as Dr. Buzzard referred to it, his mantle of dealing with the supernatural. The policemen and jailer, taking their time, slowly finished their dinner and then walked back to the jail. They carried on a conversation as they leisurely strolled back to the jail. "What if Dr. Buzzard couldn't get out

of the coffin. He might be dead," said the jailer. "There are plenty of people here in Beaufort that wouldn't mind him not ever getting out of the coffin," said a policeman. "Well, if I hadn't closed the coffin he might have put a hex on me," replied the jailer. "We shouldn't have left him in the coffin for such a long period of time," replied one of the policemen. As they rushed into the jailhouse almost in a panic, their hearts pounding with fear that they may have killed Dr. Buzzard, they came to a sudden stop. The chains were scattered all over the floor. The jailer ran to the coffin and hurriedly opened the lid. To their shock and disbelief, a black cat jumped out. Dr. Buzzard was nowhere to be found.

Ridgeville Bigfoot

The year 2007 brought a number of Bigfoot sightings in South Carolina. On Sunday, January 14, 2007, in Berkeley County near Ridgeville, a newspaper carrier spotted one. At about 6:45 a.m., it was dark and partly cloudy. The newspaper carrier was making his usual deliveries when the headlights of his car caught something to his left. The carrier noticed a big shadowy figure walking along the edge of the woods near a cornfield. The best the carrier could tell in the dim light, it was big and appeared

solid black. It appeared to be six to seven feet tall. As the carrier neared the dark, shadowy figure, it stopped and turned toward him. All he could make out was the big dark outline of the figure. No details on the face were visible except for the red glowing eyes. After a few seconds, it turned away and walked off into the woods.

JACKSONBORO

Long before it was the settlement of Jacksonborough, it was the Indian village of Pon Pon. In 1701, John Jackson was granted land along the Edisto River. Jackson named the settlement after himself. Jacksonborough grew for thirty-four years before becoming recognized as a settlement in 1735.

In 1744, a Methodist and an Episcopal church were built in Jacksonborough. In 1744, the first free school was established in Jacksonborough. In 1780, a plan of Jacksonborough showed 113 lots. That same year, Jacksonborough became the county seat. To meet the needs of a growing community, a courthouse and a jail were built. Another milestone for the area was in the spring of 1782, when the *South Carolina Gazette* was published at Parkers Ferry, just a few miles from Jacksonborough.

In February 1780, while the British were attacking Charles Town, the general assembly was meeting in Jacksonborough. Peter DuBose, the owner of the Masonic Lodge and a tavern, granted the use of his buildings for the Senate and the House to meet in. Jacksonborough became the provisional capital of South Carolina. Later that year, a railroad was built from Jacksonborough to Green Pond.

On August 10, 1793, Jacksonborough was granted the establishment of a post office. The first postmaster was John Adcock. The post office has been in continuous operation since 1793. On November 28, 1892, the name was officially changed to Jacksonboro.

PON PON CHAPEL OF EASE

The Chapel of Ease was established on Parkers Ferry Road in 1706. Parkers Ferry Road was the stage route that connected Charles Town, South Carolina, to Savannah, Georgia. Shortly after the church was completed,

missionary Nathaniel Osborn of the Society for the Propagation of the Gospel arrived to hold services in the chapel.

In 1715, St. Bartholomew's Parish was devastated by the Yemassee Indians. In 1725, by an act of the general assembly, Pon Pon Chapel of Ease was one of two churches serving St. Bartholomew's Parish. In 1754, a brick chapel was built to replace the older wooden building. Between 1796 and 1806, the Pon Pon Chapel of Ease was burned; it has since been known as the Burnt Church.

The chapel's historical importance is partly due to the fact that John Wesley preached two sermons there on April 24, 1737.

The Pon Pon Chapel of Ease was listed on the National Register of Historic Places on January 5, 1972. A historical marker for the chapel is near Jacksonboro in Colleton County on Parkers Ferry Road. The inscription on the marker reads:

> *1706 Parish established*
> *Reverend Nathaniel Osborn, Missionary of the S.P.G. arrived*
> *1715 Parish devastated by Yemassee Indians*
> *1725 Act Of General Assembly provided for a Chapel Of Ease here to be*
> *used as a Parish church until one should be built*
> *1737 John Wesley preached here April 24th*
> *1753 Vestry ordered a brick building to replace wooden Chapel*
> *Building was burnt between 1796 and 1806*
> *Has since been known as "The Burnt Church"*

THE JACKSONBORO LIGHT

Another town, another deserted road and another ghost light. This story comes from the late nineteenth century. One night, a young girl ran away from her home. When her father went to check on her, he found her missing. Immediately, he set out in search of his missing daughter. It was late at night, and he was carrying a lantern as a means of light. As the lantern burned its last flicker, her father lost his way in the dark. He continued to search for her even though he had no light and the woods were very dark. Losing his way, he stumbled onto the railroad track. He was hit by the train and killed.

It is believed that at certain times you can see the lantern. To see the light, take Parkers Ferry Road and drive about two miles until you see a church

on the left. Turn around and drive back until you can see about one mile of road straight ahead. Stop, turn off your car and flash your headlights five times. Sit quietly and listen for a train in the distance. At about the same time you hear the train, the light will appear down the road in front of you. Wait a few minutes and the light will come toward you. Some have reported seeing the shape of a lantern, while others report seeing the faint shape of a man carrying a lantern. Sometimes the light will appear and then disappear just as quickly. Sometimes when it disappears, it will reappear behind you.

BIGGIN HILL CHURCH

In 1704, St. John's Berkeley Parish took its name from the act of assembly of 1704. This act was followed by the church act of 1706. At that time, the parish of St. John's Berkeley was the largest of the ten original parishes in the province.

The site on which the church is located is believed to have gotten its name from Biggin Hill in Kent, England. I have not found any record of why it was named that.

In 1707, the Huguenots allowed Reverend Robert Maule, an Anglican missionary who came to their province, the use of their church twice a month. There were no Anglican churches in the area. In the years to come, this would lead to the absorption of the Huguenot congregation by the Anglican parish. An Anglican church would be built on Biggin Hill and completed in 1712.

In 1756, a huge forest fire swept through the area, taking with it everything in its path, including Biggin Hill Church. In 1761, the church was rebuilt. In 1781, the church was damaged by fire set by the British under the command of Colonel Coates. It was restored and once again used as a church. After the Revolution, Biggin Hill Church was restored again and used until nearly the end of the Confederacy. During the Civil War, the inside was stripped for materials. In 1886, the stripped and unused church building was once again destroyed by a forest fire.

The growth and community interest caused St. John's Berkeley Parish to be divided into three parts: upper, lower and middle. The church was now in the lower part of St. John's Parish. The ruins found there are believed to be the remains of the church built in 1761. The site of the Biggin Hill Church ruins is located in Berkeley County.

THE GHOST OF EDINGSVILLE BEACH

Before the beginning of the Civil War, the planters on Edisto Island planted sea-island cotton. Many of the plantation owners became millionaires in a short period of time. They built elaborate homes on Edingsville Beach, across the tidal creek from Edisto Island. The houses were built facing the sea, with large porches for entertaining. Most of the houses were built in the same architectural style.

Mary Clark, daughter of one of the planters, got engaged to Captain Fickling. Both were descendants of old families. Mary Clark and Captain Fickling grew up together on Edisto Beach and were childhood sweethearts. As the families were preparing for the upcoming nuptials, no expenses were spared. The wedding day finally arrived, and the families and guests begin arriving. The bride, on the arm of her father, walked under the cover of the native vegetation. As they walked down the aisle at St. Stephen's Church, the groom waited at the altar. Mary Clark and Captain Fickling were pronounced man and wife. The married couple received their guests in the churchyard. The guests were invited to a feast on the beach fit for the royal family. The food was prepared by the best cooks on the two plantations from recipes handed down from generation to generation.

In early October, about a month after the wedding, Captain Fickling set sail for the West Indies. Mary anxiously awaited her husband's return. He did not return at the appointed time, and Mary began to worry. He was now long overdue, and Mary was almost ready to panic. She would walk up and down the water's edge each evening waiting for her husband to return.

On October 12 of the following year, the sea began getting rough. She feared a hurricane might be forming out at sea. The hurricane would be in his path and would further delay his return. There were no warning signs of hurricanes at that time, and many ships and lives had been lost during past storms. She realized that others were worried about a possible hurricane, too. The causeway to Edisto Beach had already flooded, leaving everyone on the island stranded. Within hours, the hurricane hit the island. The house Mary was staying in began to sway and started to give way. There was a great sucking noise, and all the candles went out as if the air had been sucked out of the house. Total darkness set in as the sea began to wash up into the house. The family members sat fearing for their lives.

As the sun came up the next morning, it brought a scene that Mary and her family would never forget. Trees were down everywhere. Some beach houses were washed away. Furniture and debris were scattered everywhere

along the beach. As Mary was surveying the hurricane damage, she noticed a dark form floating toward the shore. As she continued to watch the dark form moving in the surf, she realized it was the body of a man. She rushed down to the water's edge to pull the man ashore. As she reached down and took hold of the man, she realized it was her husband. She dropped down on her knees crying, holding the lifeless body of her husband. She later learned that his ship had been caught in the hurricane and sunk. All lives were lost. Mary's husband's body was the only one recovered.

Today, Edingsville Beach is just a hint of sandy beach. The story goes that on some nights, a girl can be seen pulling a man's body out of the water to the shore.

EDISTO ISLAND PRESBYTERIAN CHURCH

Established in 1685, the Edisto Island Presbyterian Church is one of the oldest Presbyterian churches in America. A Presbyterian congregation was meeting on Edisto Island before the church was established. The original church was built in 1710. Like many other churches, the original church was destroyed by fire, and a new church was built in 1807 to replace the old one. The present church that is in use today was built by E.M. Curtis, a Charleston builder, and was completed in 1836. There have been two dates of construction listed for the construction of the Edisto Island Presbyterian Church, 1831 and 1836. Except for some minor changes to the portico and ceiling, the church has changed very little in the last 175 years.

The church served both the white and black islanders until the beginning of the Civil War.

The manse (pastor's house) has been home to all the pastors since the eighteenth century. The pastor's house and the sanctuary are listed in the National Register of Historic Places.

The church has a large historic graveyard with many fine headstones dating back as far as 1718. This graveyard is the resting place for many Edisto Island natives. Five former pastors have been laid to rest in this graveyard, including Reverend William States Lee, the longest surviving pastor in the church's history.

Edisto Island Presbyterian Church is not without its resident ghosts. While visiting the church and graveyard, one person thought he saw something move just outside the mausoleum. Another report claims a person was taking

pictures of the church and the lights started to go on and off. Another person taking pictures of the church reported that one of the pictures contained an image of what appeared to be a young girl in a long dress looking out of one of the windows.

In the golden age of southern plantations and rich rice planters, diphtheria was the most feared of all the known diseases. No one was immune to this deadly disease. Children suffered the most deaths. One family living on Edisto Island on the northern coast had two children, a boy and a girl. The girl began to look a little paler than the boy. Nobody paid it any attention until the sore throat and fever began. She began complaining about difficulty swallowing. From there, the disease progressed rapidly. The family could do

nothing but watch their daughter die. It was just a matter of time until the young girl went to her eternal calling.

With temperatures on Edisto Island reaching upward of one hundred degrees, it was imperative to get the expired person in the grave as soon as possible. The girl's funeral was delayed several days so that out-of-town family members could arrive in time for the funeral. In the hot weather, the body should have been decomposing and the smell unbearable. But when the young girl was brought to the crypt, she was still as beautiful and fresh smelling as she was the day she died.

Because of the fear of diphtheria, the people who were to take the girl's body to the crypt did not show up for the funeral. The father had the task of taking his own beloved daughter into the crypt. The young girl was laid out in her coffin, and the father said his last goodbye. The large marble door was closed and locked. The mourners made their way home, and the family left and went home to try to pick up their lives again. Life on the plantation would not be the same without the young girl.

In about a decade, the drums of the Civil War began to beat. Life as they knew it in the South would never be the same. The girl's brother joined his regiment and was off to war. The next time the family saw their son, he was in a pine box, a casualty of war. A quiet funeral was held, and the coffin was brought to the family crypt. As the door swung open, another nightmare was unveiled. The clattering of the bones of the young girl who had been placed in there almost a decade earlier was heard as the crypt door was opened. The gown that she had been buried in was still clinging to her remains. A piece of the cloth was hanging on the inside of the crypt door. It seemed the young girl was in a coma when they laid her to rest. The family had buried their daughter alive. Maybe some light from around the door had drawn her there in hopes of escape. The girl's remains were once again laid out, and her brother was placed beside her in the crypt.

Shortly after everything was over, a caretaker found the crypt door slightly open. The family was immediately notified, and the door was once again closed and locked. Shortly after that, it was found wide open. Again it was closed and locked. This went on for some time before a permanent solution was found: the door was sealed. This didn't stop the door from opening. This time it was found on the ground. The remains of the family members who had been placed in the tomb were removed and buried in another place in the cemetery. The door was then embedded in the floor of the crypt. The door still remains there.

HILTON HEAD RANGE LIGHT

In 1663, sailing for King Charles II of England, Captain William Hilton sailed into Port Royal Sound. On the southern side of the entrance to Port Royal Sound on the northern end of the island was a high bluff. Captain Hilton marked the island on his chart as Hiltons Head. The name was later changed to Hilton Head. Captain Hilton opened the way for more ships to sail into Port Royal Sound. Many ships did not make it into the sound for lack of navigational skills.

The first recorded lighthouse built on the island was believed to be built by the Union army while stationed there during the Civil War. The light stayed in use for about six years until being destroyed by a severe storm in 1869.

Seeing the need for another light, Congress approved $40,000 for a pair of range lights. Work began on the pair of range lights sometime between 1879 and 1880. They were not completed until 1881. The front light was built atop the light keeper's house. The other light was a six-legged tower standing ninety-five feet high and served as the rear light. The rear light was positioned about a mile and a quarter inland from the front light. When the ships were entering Port Royal Sound, the captain would line up the two lights so that the back light was positioned above the front light. When the two lights were lined up, the captain knew he was in the right channel.

By 1884, the channel was shifting. Following the range light now could prove disastrous for ships. This created a need to realign the two lighthouses. A mobile front-range light was built in order to track the changing channel.

In 1898, seventeen years after the lighthouse was lit, a fierce storm hit the island. The lighthouse keeper, Adam Fripp, and his daughter Caroline stayed in the lantern room keeping the light burning. In the pounding rain, Fripp had to go to the oil house. As he made his way to the oil house and back carrying a large container of oil, the wind and rain were taking their toll on him. Fripp, braving his way back to the lighthouse, managed to get up the stairs. As he made his way to the top, a powerful wind struck the lighthouse, shattering the glass and extinguishing the lantern. As Fripp reached the top of the stairs, he died of a heart attack. Caroline continued to keep the lantern burning, but the exhaustion and grief over the death of her father were too much. Caroline passed away three weeks later.

This is the only cast-iron lighthouse in the state. It was a cast iron-skeleton, and the stair tower was originally wood but later believed to be

clad with iron sheeting around 1913. The watch room and lantern room were made with wood. The lighthouse was decommissioned in 1932. It has since been restored.

During World War II, the area surrounding the lighthouse became Camp McDougal, a training camp for the Southeastern Seaboard Patrol.

The lighthouse and surrounding land was later sold to the Greenwood Development Company. In the 1980s, the lighthouse was incorporated into the Arthur Hills golf course.

The front-range light no longer exists. The existing lighthouse is also known as the Leamington Lighthouse.

HAIG POINT RANGE LIGHT

Haig Point reaches back to the colonial times. A Scottish merchant named George Haig purchased the property in 1733. The property purchased by Haig was located at the north end of Daufuskie Island. The land remained in the Haig family for three generations.

In 1810, George Haig III sold the Daufuskie Island property to the Mongin family. In 1833, Herman Blodgett bought Haig Point Plantation from the Mongins. Blodgett built an impressive southern mansion with an oak-lined road leading to the mansion. He also built slave quarters on the plantation. In 1850, Blodgett sold the Haig Point Plantation to Squire Pope. Pope also owned several large plantations on Hilton Head.

The tranquil southern plantation life was about to be interrupted when the Yankees arrived on the Sea Islands in 1861. After the end of the Battle of Port Royal on November 7, 1861, the Union soldiers headed toward Savannah, Georgia. As they passed by Daufuskie Island, they saw the mansion on Haig Point Plantation. They decided that the boards would make a good road across the boggy John's Island. The mansion was stripped of wood by the Yankees, and the remains of the mansion were burned.

After the Civil War was over, the government rebuilt lighthouses along the coast. Many of the lighthouses had been destroyed or damaged during the war. The government built range lights on the northern end of Daufuskie Island for two reasons: to guide ships into Calibogue Sound and to ensure the ships' safe passage between Port Royal Harbor and the Savannah River.

On March 3, 1871, Congress made available funds for the two lighthouses and five acres of land on Haig Point. A three-acre plot on the northern end

and a two-acre plot 750 yards to the south were bought from the Pope family. In December 1822, James Reed of Washington, D.C., was contracted to get the materials for the two range lights and the keeper's house, transport the material to the island location and hire the needed labor to build the two range lights for $7,681. The keeper's house was a two-story dwelling built on the foundation of Blodgett's plantation mansion.

Over time, the entrance to the sound would move due to the currents and shifting sand. The front-range light was built on top of two wooden rails so it could be moved to align with the entrance to the sound. A fifth-order Fresnel lens produced a steady white light from the rear tower. A steamer lens was used in the front tower.

On August 29, 1873, Patrick Comer was appointed as the first caretaker of the two lights. Comer's wife, Bridgett, would serve as the assistant caretaker. The Comers activated the two lights for the first time on October 1, 1873.

In 1886, the Charleston earthquake shook the lighthouse, causing the plaster to fall off the interior walls. There was no other damage to the lighthouses.

After serving eighteen years as the lighthouse keeper, Patrick Comer passed away in 1891. In that year, Richard Stonebridge was appointed to take Comer's place. Stonebridge retired on July 1, 1923. Charles Sessions was appointed the third keeper of the Haig Point Lighthouses. A year later, the use of the Haig Point Range Lights was discontinued.

In 1925, the government sold the range lights and the five acres of land surrounding them through sealed bids. Mr. M.V. Haas from Savannah, Georgia, put in the highest bid: $1,499.99 for the package. The lighthouses passed through several owners during the next few years. In the 1930s, they were used as a hunting lodge. Several parties were held there during that time. One night, one of the party guests got drunk and went up to the top of the lighthouse and leaned against the wooden railing. The railing broke, and the partygoer plunged to his eternal calling. During the following years, the lighthouse was no longer used and slowly deteriorated.

In 1961, George Bostwick bought Haig Point Plantation, and in 1965, he bought the lighthouse. In 1967, he set out to repair and restore the desolate ruin that had stood watch for so many years from Daufuskie Island.

On October 23, 1984, International Paper Reality Corporation bought Haig Point with plans to develop a resort community. Archaeologist Larry Lepinoka and historic architect Colin Brooker were hired to date the slave ruins and find the mansion's foundation. The foundation was preserved

instead of destroyed. Using the original plans, the lighthouse was restored under the supervision of Bill Philips. On October 18, 1986, Haig Point Lighthouse was once again lit in a festive ceremony as fireworks lit up the sky.

Today, the lighthouse is used for guests of the Haig Point community. People have reported hearing footsteps going up and down the stairs but have made no connections to previous tenants or owners.

CHILDSBURY

The town of Childsbury no longer exists, but it is very significant as an archaeological site. An English settler named James Child was granted 1,200 acres on Strawberry Bluff overlooking the Cooper River on July 14, 1698. Child came to the area from the county of Buck, England. Strawberry Bluff was the farthest point upriver that a ship could travel. Child received 1,500 more acres in grants from 1709 to 1716. At one time, Childsbury had a tavern, a school, a chapel, a racetrack, a general store and a ferry. James Child designated property for a college, a free school, a house for the schoolmaster, a place of worship and a market square. He also designated 600 acres for farmland and pasture land and 100 acres on the bluff for a citadel. As the town continued to grow, a tanner, a butcher, a shoemaker and carpenters moved in. The streets in Childsbury were named Craven, Mulberry, Church, Ferry, Blackwell and Bay.

James Child started a ferry from his property. This was the only practical location for some distance for a ferry to cross the Cooper River. Childsbury was a bustling town before the Civil War. Due to the rise of new plantations and the growth of present plantations, Childsbury began a rapid decline. It would eventually become part of a plantation.

Strawberry Chapel is the only remains of Childsbury. It is a parochial chapel of ease that was located in the lower part of St. John's Berkeley Parish in Berkeley County. It was built in 1725. There are a number of legends surrounding Strawberry Chapel. One is true. The story of Catherine Chicken at the age of seven was tied to a tombstone one dark night by her schoolmaster in 1748. Catherine Chicken was rescued by a servant. She survived the night. There was an uproar from the towns people and the schoolmaster was driven from the town.

HAGOOD'S MILL CEMETERY

I could not find much information on Hagood's Mill Cemetery in books or on the Internet. Many local people were reluctant to talk about it, and none would give the exact location for fear of vandalism. None was interested in talking about it as a haunted cemetery. Most would tell me it's not haunted. The only information I could get about the location is that it's off Highway 64 outside Barnwell. You have to walk about a mile through the woods. The first thing you will see is a wrought-iron gate. This cemetery is set up a bit unusually. The gravestones are arranged in a circle, with the oldest beginning in the center and then moving out. I could not get any dates or names of people laid to rest there.

There are several stories of haunting in the cemetery. The most popular one is about floating lights—yellow, green and blue—that float around the cemetery. These lights are reported to move around the cemetery and out into the nearby woods. At times, the lights will go straight up and then come back down and disappear. There is another story about a skeleton dog moving around the graveyard or in the nearby woods. In some reports, people have seen the skeleton dog cross in front of them on a nearby road. Is this ghost dog protecting its master? So far, no links have been made between the dog and anyone laid to rest in the cemetery.

MEDWAY PLANTATION

Medway Plantation is located on the Back River, which flows into the Cooper River near Goose Creek in Berkeley County. The name is believed to come from the Medway River near Exeter, England, the home of Thomas Smith, the first landgrave. A landgrave was the head of the territory.

In 1686, Jan Van Arrsens was granted land and all rights of barony by the Lords Proprietors. In 1686, Van Arrsens built the house for his wife, Sabrina de Vignon. The young couple had come from Holland to settle in America. The Van Arrsens never had any children. They spent their time caring for the home and landscaping the yard. Caring for a twelve-thousand-acre plantation took up all their time.

For more than three centuries, the house has remained there, sheltered by the huge moss-covered oak trees once planted by the Van Arrsens. It is believed to be the oldest brick house in South Carolina. Van Arrsens, being

a Dutch nobleman, built his home to rival those of Europe. The bricks were made and dried on the plantation. One unique feature about the house is that the central part of the house has stair step gables for the spirits to go down instead of going into the house.

Van Arrsens died and left his wife alone with the plantation to care for. He was buried on the plantation, but like so many back then, there was no permanent marker placed on his grave. Van Arrsens's grave can no longer be found. With the plantation and home to care for and not wanting to live alone, Sabrina Van Arrsens soon married Thomas Smith. Smith had a home in Charleston, but they decided to live on Medway Plantation. Smith became governor in 1693, and Medway and his home in Charleston became the centers for the colonial social life. Smith passed away on November 16, 1694. He was buried on Medway Plantation. His grave is marked by a heavy slab. Smith's sons from another marriage would later inherit Medway Plantation.

Thomas Drayton later owned the plantation and sold it to John Bee Holmes. In 1797, Theodore Marion bought the plantation from Holmes. In 1827, Marion died, leaving Medway to his grandson Theodore Dubose. In 1833, Peter Stoney bought Medway. In 1906, Samuel Stoney bought Medway from Peter Stoney. In 1929, the Legendres bought Medway from Samuel Stoney. Bokara Legendre later inherited the plantation and was the owner in 2010.

No South Carolina plantation comes without its resident ghost. Jan Van Arrsens's ghost is believed to still keep residence at Medway Plantation. His ghost began appearing shortly after his death. A man dressed in the clothing styles of Holland in the 1600s has been seen sitting in a chair in front of the fireplace and smoking a pipe.

PURRYSBURG

There are no ghost stories here; this is just another town in South Carolina that bit the dust. On the bank of the Savannah River stands a lonely cross-shaped monument as a grim reminder of a town that no longer exists. The monument was erected in the 1940s by the Huguenot Society of South Carolina.

The story begins in Neufchatel, Switzerland, with one of Switzerland's most adventurous people, Jean Pierre Purry. Purry was born in Neufchatel in

1675. By 1713, he had left Switzerland in search of his fortune. He traveled to the West Indies and South Australia in his hunt for new lands to colonize. In 1718, Purry published his theory that the best place to live was in America, thirty three degrees north and south latitude. That is what brought Purry to the banks of the Savannah River in 1731.

In 1724, Jean Pierre Purry proposed to the Duke of Newcastle a Swiss settlement in America. Purry suggested that the colony be named Georgina. The Lords Proprietors of Carolina were anxious to better settle the frontier of South Carolina. They agreed to transport Purry's group to America at the proprietors' expense. In 1726, three hundred people showed up to go with Purry to America. At the last minute, the Proprietors changed their minds about the deal. They were not going to finance Purry's trip to America. In 1729, the Lords Proprietors relinquished control of the South Carolina colony to the Crown. Purry revived his plans in 1730, and by 1731, he was in South Carolina.

Purry's plans for a colony in America would fit into the highest-priority instructions from the king's ministers to the first royal governor of South Carolina, Robert Johnson. Johnson was instructed by the Crown to establish townships in South Carolina's frontier. Purry was led to the banks of the Savannah River by Captain Roland Evans, one of the Carolina Rangers. The site that Purry chose for the township was called Great Yemassee Bluff. It was on the South Carolina side of the Savannah River. The name Purry chose for the township was Purrysburg.

In 1732, settlers cleared the site and laid out the lots for Purrysburg. By 1736, there were one hundred houses and 450 settlers living in Purrysburg. Over the next decade, due to harsh living conditions, most of the settlers sought better lives across the Savannah River in Georgia. Many Purrysburg settlers moved to the town of Savannah and the Salzberger settlement, which had recently been established.

In 1736, Jean Pierre Purry died, leaving his wife, Lucrece de Chaillet; two sons, David and Charles; and the remainder of the people in the township to fend for themselves. None of Purry's sons remained in Purrysburg. At that time, David was in Europe and remained there. Charles became a prominent merchant in Beaufort, South Carolina. In 1754, Charles Purry was poisoned by one of his slaves. This ended the Purry family in America.

Purrysburg only survived because it was a principal crossing area of the Savannah River on the king's highway from Charleston, South Carolina, to Savannah, Georgia. In 1747, Purrysburg became the seat of St. Peters Parish, established along the Savannah River. Reverend Henry Chiffelle was

sent by the Society for the Propagation of the Gospel in Foreign Parts to organize the Anglican Church. Purrysburg lingered on until the time of the American Revolution. It served as the first headquarters of the American army under General Benjamin Lincoln.

On February 25, 1822, Purrysburg was granted a post office. The first postmaster was John Keebler. The post office remained open until January 14, 1848. Today, the river landing and cemetery are still in use. These are the only things that remain of Purrysburg.

BOTTLE TREES

When journeying through South Carolina and many other southern states, you may notice unusual trees in yards. These trees are covered with bottles, not leaves. Some are adorned with blue bottles, while others have many different-colored bottles.

It was once believed that the origin of the bottle tree dated back to the Congo in Africa in the ninth century AD. Bottle trees and the folklore go back much further in time. The superstitions and beliefs surrounding the bottle tree were embraced by most ancient cultures. Glass bottles began appearing around 1600 BC in Egypt. Around that time, stories began circulating that spirits could live in bottles. These stories led to the belief in bottle imps and genies.

In the ninth century in the Congo, the natives would hang hand-blown glass on their huts and in nearby trees to ward off or capture evil spirits and to keep them out of their huts. According to the legend, the colorful bottles would attract evil spirits, which were drawn to the bottles by the burst of sunlight on the color. Once the spirit entered the bottle, it could not escape. Another legend that goes along with the trapped spirit is that when the wind blows, you can hear the spirits moaning. It is believed that the wandering spirits get trapped at night, and when the morning sun rises, the sunlight will kill the evil spirit. Another legend is that the bottles hold the spirits of their ancestors, while others believe that the bottle tree grants wishes.

During the slave period in America, slaves would put bottles in trees in hopes that the evil spirit would go into the bottle and be trapped. Once the spirit was in the bottle, the slaves would put a cork or some other object in the top of the bottle so the spirit couldn't escape. They would throw the bottle into the river to wash away the spirit.

You will run into people who refuse to put up bottle trees due to the connection to pagan superstitions. Many believe the folklore has transformed their yard or flower garden into an enchanted garden. Bottle trees have become a unique southern gardening tradition. Blue is the preferred color.

ABOUT THE AUTHOR

Sherman Carmichael was born in Hemingway, South Carolina, and now lives in Johnsonville, South Carolina. Carmichael spent thirty years as a photographer, twelve years as a model agent, fourteen years as a talent agent and twenty-three years in law enforcement. He became interested in ghosts, haunted houses, UFOs and other mysterious things at an early age. At eighteen, he began investigating haunted places in South Carolina. Over the years, Carmichael has seen, heard and felt many things that cannot be explained. In 2007, Carmichael went to work as a researcher for an independent production company that had plans to film a series on the unexplained in South Carolina. The series never finished due to the illness of the executive producer. Carmichael continued doing research, and in 2011 his first book, *Forgotten Tales of South Carolina*, was published. Carmichael continues to do research and investigations into the strange and unknown.